IMAGES
of America

ST. MARYS

D1501502

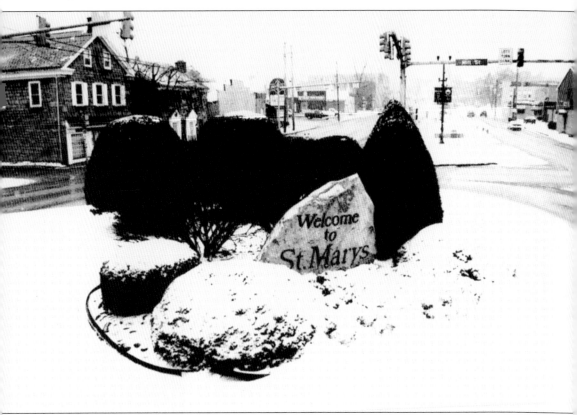

Most visitors to St. Marys arrive from the south on Route 255. They are greeted to the downtown area on the General Edward Meyer Boulevard. Local native Edward Meyer was the chief of staff of the U.S. Army during the late 1970s. The boulevard now covers the area on Elk Creek where St. Marys was founded. (Courtesy Debra McGeehan.)

On the cover: Seen here is the southwest corner of the Diamond during the Old Home Week Festival in 1906. Buildings are, from left to right, Vey Building, Hall and Kaul Hardware Store, St. Marys Gas Company building (behind tree), and Koch building, with the St. Marys Post Office on the ground floor. Still remaining on the Diamond at this time are the iron water fountain, cement walkways, and cannons. (Courtesy St. Marys and Benzinger Township Historical Society.)

IMAGES
of America

ST. MARYS

Dennis McGeehan

ARCADIA
PUBLISHING

Published by Arcadia Publishing
Charleston SC, Chicago IL, Portsmouth NH, San Francisco CA

Printed in the United States of America

Library of Congress Catalog Card Number: 2005938875

For all general information contact Arcadia Publishing at:
Telephone 843-853-2070
Fax 843-853-0044
E-mail sales@arcadiapublishing.com
For customer service and orders:
Toll-Free 1-888-313-2665

Visit us on the Internet at www.arcadiapublishing.com

*This book is dedicated to Deb,
my lovely other half, who has taken me
to places I'd never been.*

CONTENTS

ACKNOWLEDGMENTS

I would like to thank all of the people who helped me in the preparation of this book: Debra McGeehan for her tireless work at every stage of the process, without whom this book would not have been possible; Ray Beimel for his encyclopedic knowledge of St. Marys history; Dick Dornisch for his years of advice and information; Bill Bauer for his extensive knowledge of railroad history; Paul and Bill Krellner for sharing their knowledge of mining; James O. Auman for his lively conversation and historical research through many years; Mary Miller and Jeanne Dostal for their hours of painstaking editing; Andrew Kaul IV; William Conrad; Donald Fleming; Percy Buttery; John Dill; Bob Beimel; Frances Hack; John T. and Elizabeth D. McGeehan for everything; the late Charles Schaut for his pioneering work in St. Marys history; and the late Edwin Grotzinger, who donated his archives of photographs to the St. Marys and Benzinger Township Historical Society.

I would also like to thank all fellow directors, past and present, of the St. Marys and Benzinger Township Historical Society who have organized, analyzed, and interpreted St. Marys history, whose material I have mined, and all of the writers of the *Grist From Old Mills* newspaper column.

All photographs, unless otherwise noted, are courtesy of the St. Marys and Benzinger Township Historical Society.

INTRODUCTION

German Catholics from Baltimore and Philadelphia founded St. Marys in 1842. The first settlers stayed in Centerville, the present town of Kersey, and walked the four miles to the proposed site of the new town in wintry conditions on December 8, 1842, the feast day of Mary, to found the settlement. The town was christened Sancta Marienstadt or St. Marys. The early settlement was communal but quickly moved away from that style as prosperity developed. Many of the early settlers were farmers and tried their hands at agriculture, but first the dense forest had to be cleared. Farming remained an important occupation, but many residents soon realized that the forest was a valuable resource. St. Marys became an important lumbering town due mainly to the investments of Sen. J. K. P. Hall and Andrew Kaul. These men set up a sawmill that quickly became the most important early employer of the young town. Many secondary businesses developed from the forest products industry, including a large tannery.

Religion was the motivating factor in founding the new settlement, so the residents of St. Marys contacted Redemptorist priests to provide religious support to the area. The Redemptorists suffered many hardships in the wilderness location and were soon recalled by their superiors. They were replaced by Benedictine priests, and soon, Benedictine nuns founded the first Benedictine convent in the United States in St. Marys and assumed the duties of teaching the children of the settlement.

St. Marys's prosperity was insured when, in 1863, the Pennsylvania Railroad came through St. Marys and brought with it many Irish railroad workers and the St. Marys population began to diversify. The Pittsburg, Shawmut and Northern Railroad line also came through St. Marys and, with the many narrow-gauge logging railroads, made St. Marys an important rail center.

Mining became an important industry when coal and clay were discovered. The St. Marys Coal Company and many individual mining operations used shaft mines to dig coal. St. Marys became an important center in the manufacture of clay products, including fire resistant bricks, sewer pipes, and building blocks.

Foreseeing the eventual decline of the extractive industries, Andrew Kaul attempted to diversify St. Marys's economy. He brought in John Speer, and in 1899, they founded Speer Carbon Company. In 1904, Harry Stackpole, a relative of J. K. P. Hall, came to St. Marys and founded a battery factory that used carbon. Stackpole Carbon Company eventually became the largest employer in the county. By the middle of the 20th century, St. Marys had become the "Carbon City" as several new carbon companies had blossomed and St. Marys became the leading manufacturer of carbon products in the world. In the 1980s, when Stackpole Carbon Company declined and eventually left town, many thought St. Marys would also decline. However, within

a decade, all of the jobs were back as St. Marys moved into the powdered metals field and led the world in that technology. Numerous tool and die businesses support the industrial sector of the region. Sylvania Electric Company was another leading manufacturing concern, producing light bulbs and electrical components.

During the several weeks surrounding the first day of fishing or hunting season, St. Marys fills up with sportsmen. St. Marys is located on the mid-continental divide with streams originating in the city, which flow in one direction to the Atlantic Ocean and in the other direction to the Mississippi River. The many headwater streams make the area popular with trout fishermen. The region is still heavily forested with second growth timber. Hunting is pursued avidly, as St. Marys people are well known for their love of the outdoors. Venison Christmas sausage is a local favorite as well as fresh caught brook trout in season. German cuisine can still be found in area restaurants.

Many of the early settlers who came were blessed with large families that continue to live in the area. They continue to identify with their German Catholic roots, and this helps to explain St. Marys residents' fascination with their own history. The town supports an active historical society and several festivals throughout the year.

St. Marys is proud of several famous citizens of note including: Gen. Edward Meyer, chief of staff of the U.S. Army; Sr. Benedicta Riepp, OSB, founder of the first Benedictine convent in the United States; Sebastian Wimmer, engineer; Andrew Kaul, lumber baron; J. K. P. Hall, businessman; H. C. Stackpole, industrialist; Peter Straub, brewer; George "Rube" Waddel, Baseball Hall of Fame pitcher; and Dan Conners, all-pro football player.

There are many unique places in St. Marys of special interest, such as Decker's Chapel (one of the smallest churches in the country), St. Joseph's Benedictine Convent (the first in the United States), Straub Brewery (an old family-owned business), one of the only free-roaming elk herds east of the Rocky Mountains, and the nearby Allegheny National Forest. Residents and visitors alike have fallen in love with the special place that is St. Marys.

One

THE FAITH
OF THE FOUNDERS

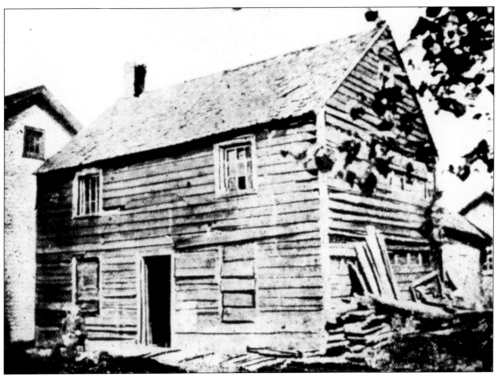

The John Walker Home was located on South St. Marys Street. John Walker was one of the first settlers. His log home was later enlarged to two stories and eventually sided. The structure was the first substantial dwelling and served as a commissary to the other settlers. This photograph shows the building near the end of its usefulness.

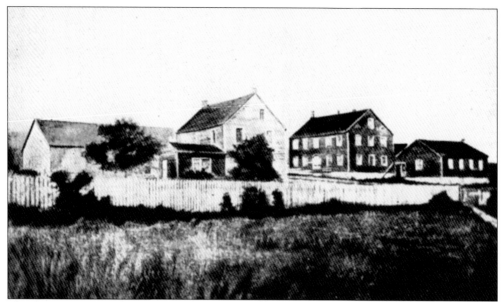

The first group of religious buildings in the community was located near where the present hospital now stands. This complex was built in 1846 by the Redemptorist priests and also occupied by the School Sisters of Notre Dame, who taught school there. Both groups soon left the colony. In 1850, the first wooden church in this complex burned and the church moved into another of the buildings.

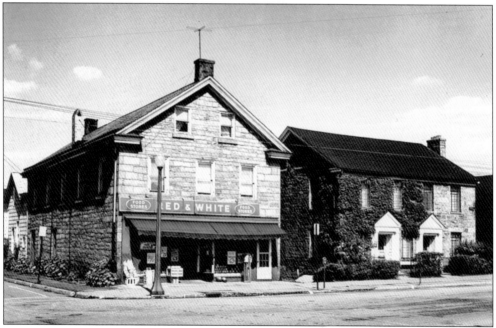

The building on the right was the first stone building erected in the colony in 1845 by George Weis at the corner of South St. Marys Street and West Mill Street. Later it became the Meisel Funeral Home. Today it is known as the Fleming Building and houses the Stackpole-Hall Foundation. The building on the left was the store and harness shop of Albert Weis, and later, Weis Funeral Home.

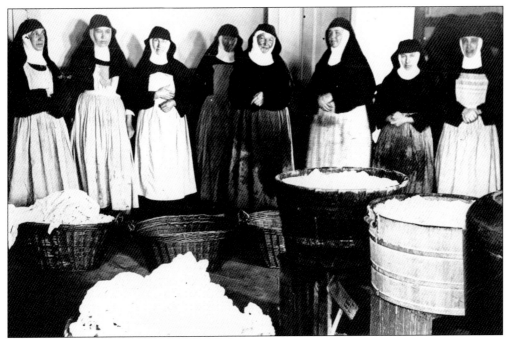

In 1852, Benedictine nuns arrived in the colony to found the first Benedictine convent in the United States. The nuns have been an invaluable asset to the community ever since. They taught school for over 100 years and ministered to the colony in countless other ways. They still reside in the convent on Maurus Street. Shown here is an early photograph of the nuns on wash day.

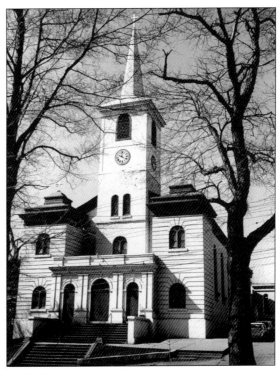

St. Marys Church, known as the German Church, was built from 1853 to 1857 on Church Street. It was a community project, built by local workers from local sandstone. The project was directed by Fr. Benedict Heindl and Ignatius Garner. The first mass was celebrated on December 8, 1853. The current stained-glass windows and vestibule were added in 1910.

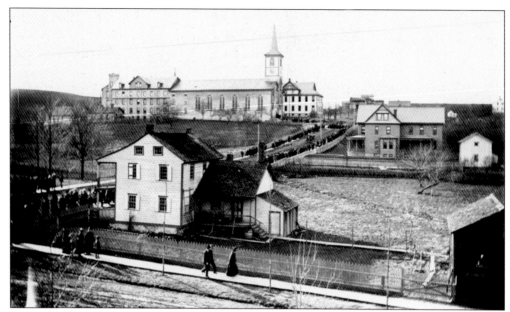

St. Marys Church and convent are located on Church Street. St. Joseph's Benedictine Convent was built onto the back of the church and occupied in 1860. To the right and rear of the church can be seen the old wooden St. Marys Parochial School, which was in use between 1896 and 1952. This photograph was obviously taken on a Sunday as churchgoers file down Church Street after mass.

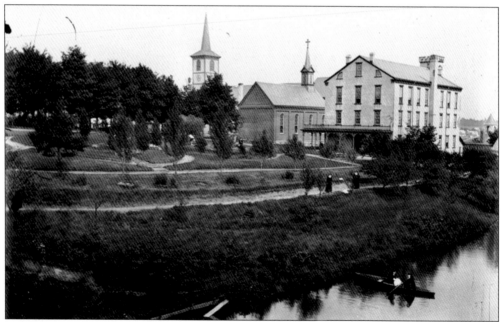

Benedictine nuns enjoy a quiet row on Lake Benita (Sisters Pond) on the convent grounds. Note the convent's formal gardens. The buildings from left to right are St. Marys Church and steeple, convent chapel (smaller steeple), and St. Benedict's Academy (a private girls school taught by the nuns). In the right background is the borough high school with bell tower, which was built in 1875 and burned in 1924.

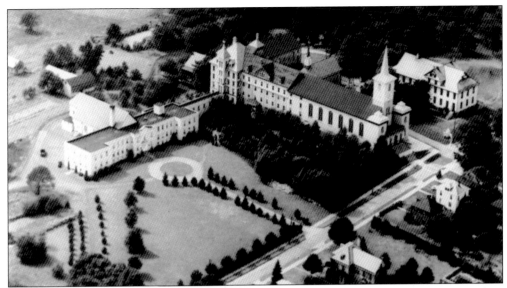

An aerial view of the St. Marys Church, school, and convent complex shows the convent building attached to the church. From left to right the buildings are the "New" building with attached large chapel, convent addition (with tower facade), original convent, St. Marys Church, and the old wooden parochial school. Attached to the convent on the school side are St. Benedict's Academy and the old convent chapel (with small steeple).

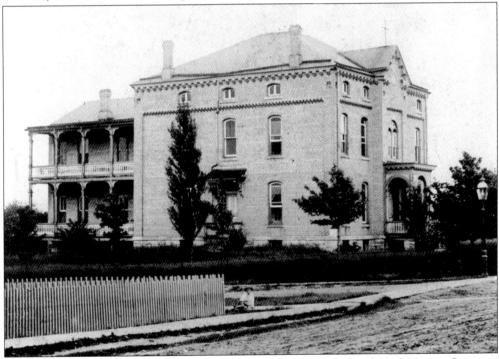

The St. Marys Parish Rectory, built in 1889, at the corner of Church and Maurus Streets is still the residence of St. Marys Parish priests. The bricks were made in St. Marys at the Quinn Brickyard. This beautiful structure was designed by local architect Joseph G. Schlimm. Note the young boy sitting by the fence and the unpaved streets.

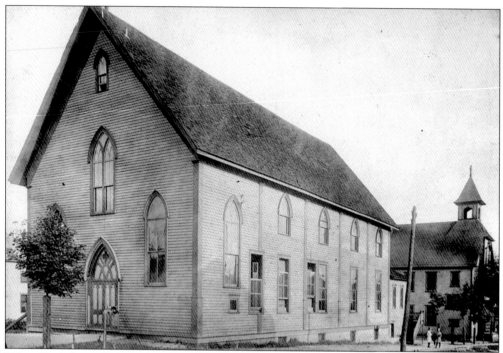

When English-speaking Irish railroaders first arrived in St. Marys, they wanted their own church, separate from what was called the German Church. The first Sacred Heart Church (left) stood on Center Street from 1876 to 1923. The school (right), built 1896 and dismantled in 1926, stood on the corner of McGill and West Mill Streets. The school building was later used as a shirt factory for two years.

St. Marys churches and schools are, from left to right, the second Sacred Heart School built in 1922, the second Sacred Heart Church built 1906 in the Gothic style, St. Marys Church steeple (background) built in 1852, and the second St. Marys Parochial School built in 1952. Center Street runs between the Sacred Heart Church and school. In the background is the Sherry Hill development.

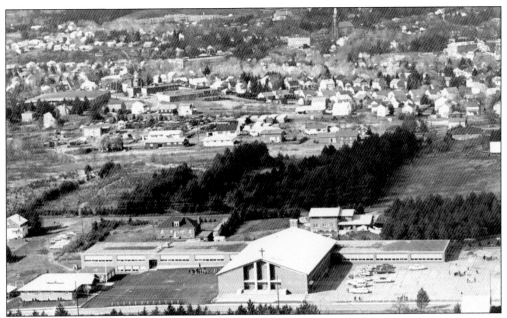

Here is Queen of the World Church and School as seen from the air. Sacred Heart Church steeple can be seen at the upper right, Elk Christian High School is in the upper left, and the Franklin Hotel, prominent in the downtown area, is in the upper right corner. The large square building, upper left, is the Corbett Cabinet Company, and to the right of that is the Spruce Street Elementary School.

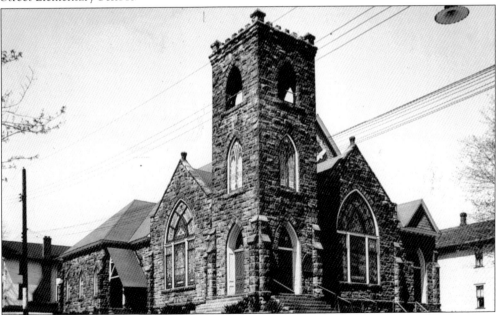

The Shiloh Presbyterian Church on Washington Street was the first Protestant church in St. Marys. The original church was built in 1868 and still stands behind the new church building, which was built between 1900 and 1903. The first Protestant service in St. Marys was held in the living room of a house across the street from the present church where the Christian Education building now stands.

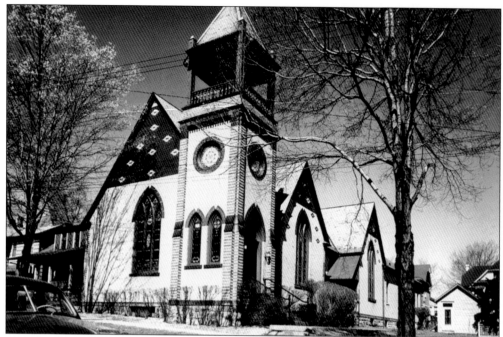

The First United Methodist Church was built in 1897 on North St. Marys Street. It was built from bricks pressed and baked at the Elk Fire Brickyard in Daguscahonda. The grand belfry was removed in the 1970s. This handsome building is covered with Shawmut yellow facing brick and red trim brick.

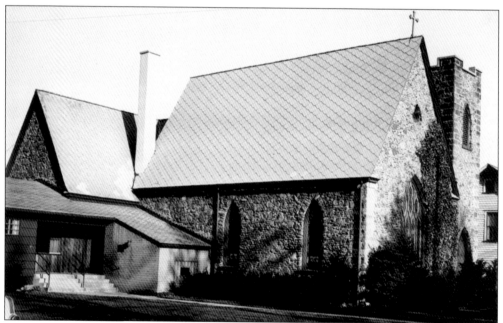

The St. Agnes Episcopal Church originally stood in Ridgway. J. K. P. Hall had the church dismantled and reassembled in St. Marys in 1904. It was consecrated in 1905 by Bishop Whitehead. In 1928, brown fieldstone veneer was added. The rectory and parish hall wing was added in 1955. Beautiful stained-glass windows adorn the interior.

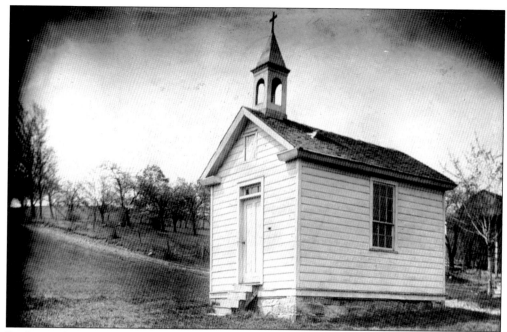

Decker's Chapel on the Million Dollar Highway was built in 1856. After a fall from a tree, George Decker vowed to build a church if he recovered. Decker's son, Michael, became a priest and often said mass here. Pilgrimages were made to the site, carrying umbrellas to pray for rain and abundant crops. During World War I, the people of St. Marys walked to the chapel to pray for peace.

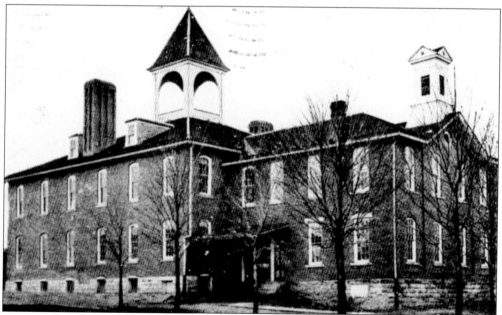

The first borough high school was built in 1875 and burned in a spectacular fire in 1924. It stood at the corner of Church and Maurus Streets. Benedictine nuns taught here until 1895, when the Smith-Garb Bill prohibited religious instruction in public schools. There were also numerous one-room elementary schools throughout the St. Marys area.

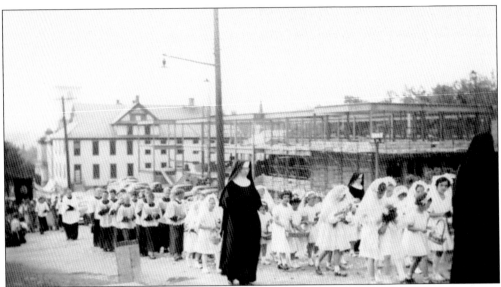

The Corpus Christi procession marches past, from left to right, St. Marys Church (steeple), the old wooden St. Marys Parochial School, and the new St. Marys Parochial School. The new school of steel with stone facing is under construction. The Corpus Christi celebration was a procession to local, temporary private shrines. This annual event is celebrated in only two places in the United States: St. Marys and Corpus Christi, Texas.

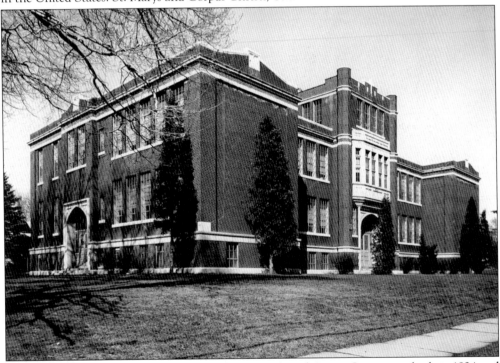

Central Catholic High School at the corner of Church and Center Streets was built in 1924 and torn down in 1992. It was constructed of tapestry brick from the Elk Fire Brick Company. The first graduating class in 1926 had 13 girls and 2 boys. The last graduating class in 1962 had 117 members. The complex also included a gymnasium and an industrial arts building.

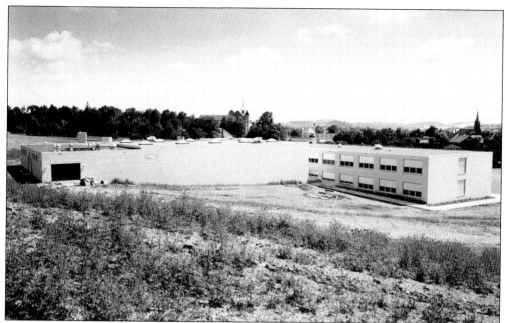

Elk County Christian High School is shown under construction in 1962. This facility replaced the old Central Catholic High School. In the background center is the steeple of St. Marys Church and in the right background is the steeple of Sacred Heart Church. The photograph was taken from Sisters Hill, in the rear of the new school.

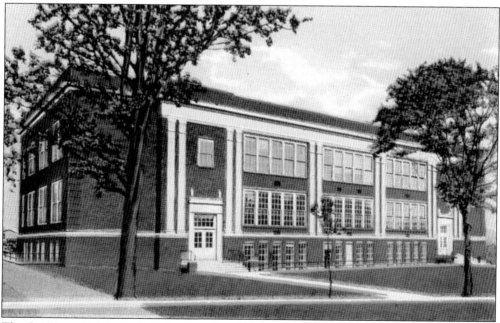

The St. Marys Public High School on South St. Marys Street was built in 1924 and rebuilt in 1991. This building served as a high school until 1969, when the new St. Marys Area High School was built. This building later served as a middle school and is currently used as an elementary school. (Courtesy Dick Dornisch.)

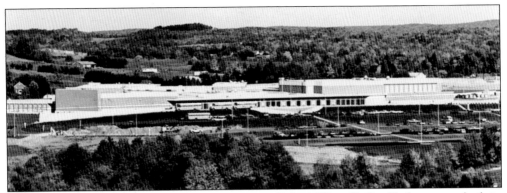

St. Marys Area High School, south of St. Marys, off the Million Dollar Highway, was built in 1969. The first graduating class was in 1970. Later a middle school was built beside the high school. Dutch Country Stadium, where football games are played, occupies the lower right corner of this view.

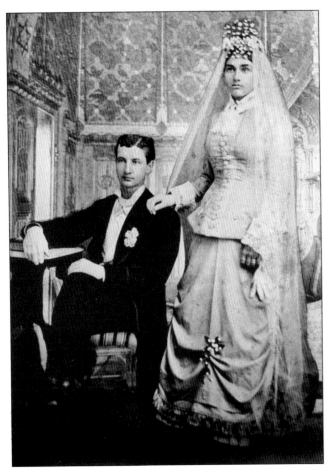

Weddings are the lifeblood of any community. When one family joins another, extended families are created and celebrated. Shown here is the wedding portrait of Anthony Kuntz and Josephine Weigel. In earlier times, often the only photographic record was a formal portrait in a studio. The convention was to have the groom seated. However, the bride's wedding dress was always distinctly her own.

St. Marys community started out with large extended families that continued to have strong family ties. The sharing of culture and tradition from generation to generation is an enduring St. Marys trait. In this 1901 photograph, Joseph Rettger is teaching his great-granddaughter Oswilla Dieteman how to play dominoes. Oswilla later became Sr. Marcia Marie, SSJ.

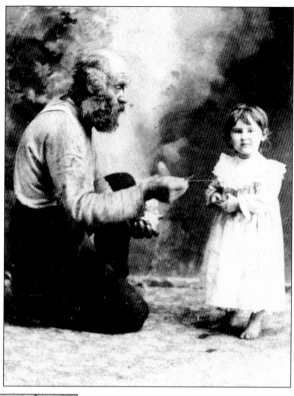

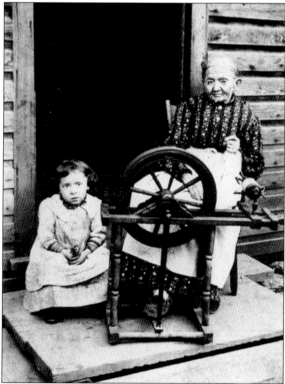

St. Marys began as a German Catholic communal experiment. For many years, St. Marys retained the roots of its German identity. Often children spoke German until learning English in the first grade. Old German customs and culture were passed down from generation to generation. Shown is Mrs. John Stauffer instructing an unidentified little girl in the use of the spinning wheel.

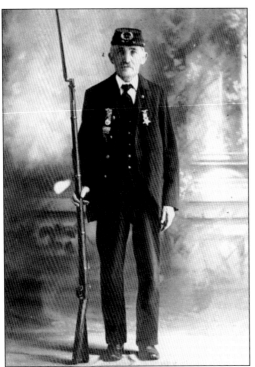

Civil War veteran Peter Andres poses with his Civil War medals. St. Marys was founded in 1842, in the troubled generation leading up to the Civil War. One of the first volunteer regiments was formed in the Elk County region. This was the famous Bucktail Regiment that garnered much praise and glory in many battles, including Gettysburg.

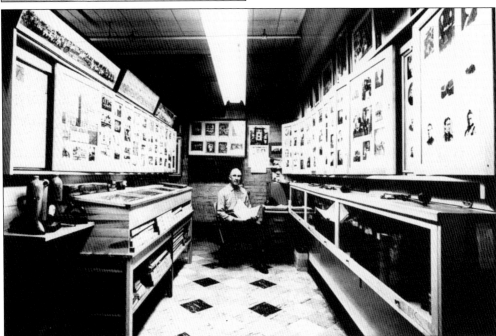

Charles J. Schaut is shown amidst the collection of the St. Marys and Benzinger Township Historical Society, which he founded. Schaut was an architect and builder whose family had early ties to the community. He wrote the reference book on St. Marys history, *Early St. Marys And Some Of Its People 1838 To 1931*. The historical society he founded is in a new building but is still located on Erie Avenue.

Two

RAILROADS

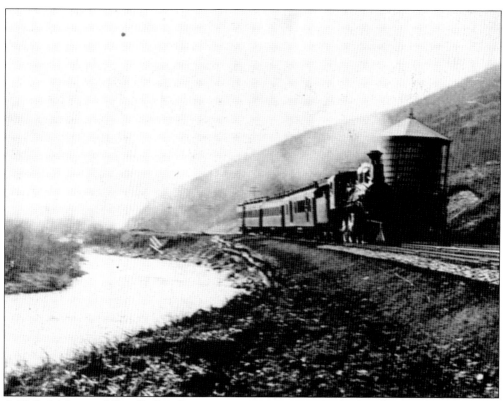

A Philadelphia and Erie Railroad passenger train stops at the Scahonda Water Tank around 1900. This tank was located just east of Daguscahonda on the banks of Elk Creek, west of St. Marys. Note the lack of vegetation in the photograph. Sparks from trains started many fires that kept the foliage burned over. There was a firefighting tram road on the hillside between St. Marys and Ridgway.

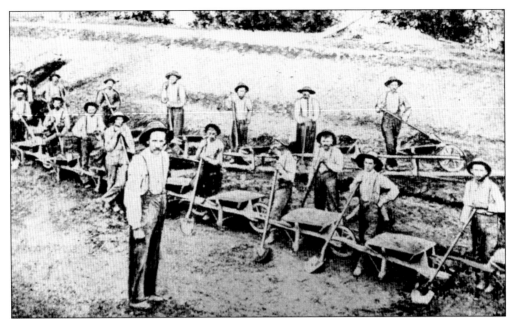

A group of railroad workers take a break for a photograph. The construction of the Philadelphia and Erie Railroad (later the Pennsylvania Railroad) through St. Marys in 1863 was an important event in St. Marys history as it brought many Irish laborers to town as well as locating St. Marys on the railroad's busy thoroughfare. This was the second significant ethnic group to enter the town.

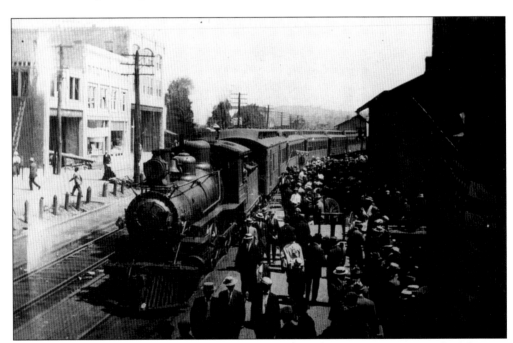

A Pittsburg, Shawmut and Northern Railroad passenger locomotive arrives in St. Marys at the passenger station on Erie Avenue. The Pennsylvania Railroad freight station is visible in the distance at the end of the train. The crowd is gathered in 1911 to meet travelers to the Convention of Catholic Societies. Note the construction on Erie Avenue in the background.

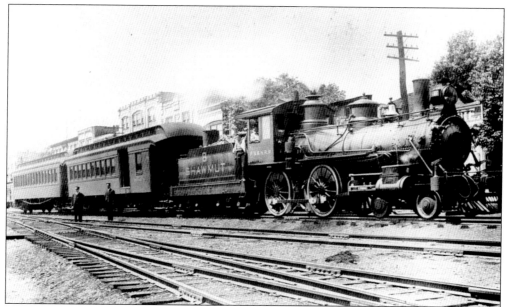

A Pittsburg, Shawmut and Northern passenger train is pictured at the St. Marys station. St. Marys was a busy railroad town in years past. A Pennsylvania Railroad train is just visible at left behind the Shawmut train. The stores along Erie Avenue can be seen above the train. The Shawmut passenger train made daily runs to Brookville, Pennsylvania, and Olean, New York. (Courtesy Bauer Collection.)

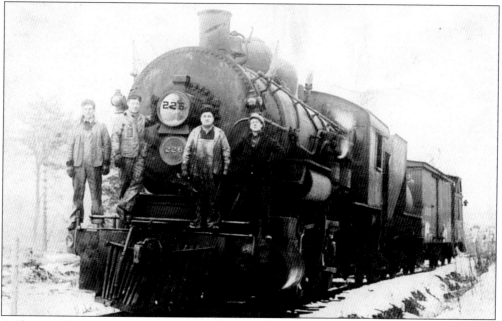

A Shawmut locomotive crew poses astride Engine No. 226 in 1914. The trainmen from left to right are Pat Ford, E. Hoffman, Al Malone, and Harry Barnell. Locomotive crews were very proud of their engines, took great pride in their performance, and were always ready for a photograph for posterity. They wore buttoned collars to keep hot cinders and dirt from going down their necks. (Courtesy Bauer Collection.)

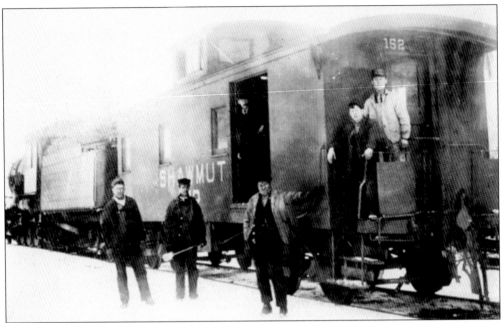

A Shawmut Railroad crew poses on their caboose for a wintertime scene. The caboose also had sleeping accommodations for the crew as runs could often last several days. Cabooses are not used on trains anymore, but many people remember the day when they could get a friendly wave from the caboose trainman. Note the ties on several of the railroaders.

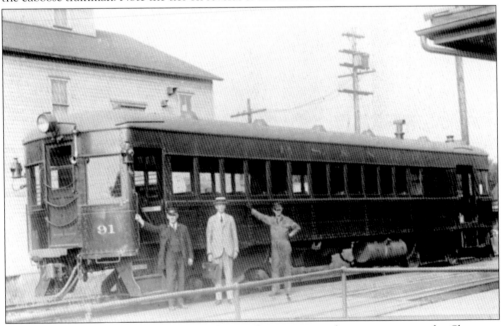

The Hoodlebug was the nickname for the gasoline motorcar for passengers on the Shawmut Railroad. It was like a bus on rails and contained one operator as opposed to three or more for a steam train. The Hoodlebug made daily runs to Olean, New York, and to Brockway, Pennsylvania, to transport miners and excursionists. All passenger service on the Pittsburg, Shawmut and Northern Railroad ended on June 15, 1935.

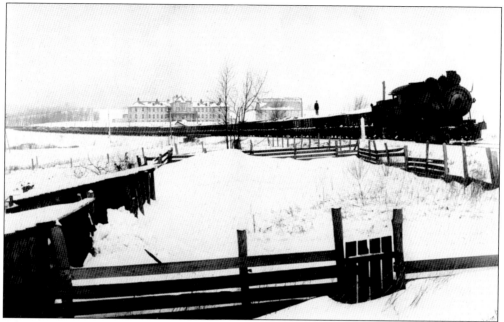

A long Pittsburg, Shawmut and Northern Railroad coal train passes by the Elk County Home. Before air brakes, a brakeman had to move from car to car and set or release the brakes as required to control the train. However, the Pittsburg, Shawmut and Northern had air brakes. What this gentleman is doing on top of this train is unknown. It appears to have been a cold job on some days.

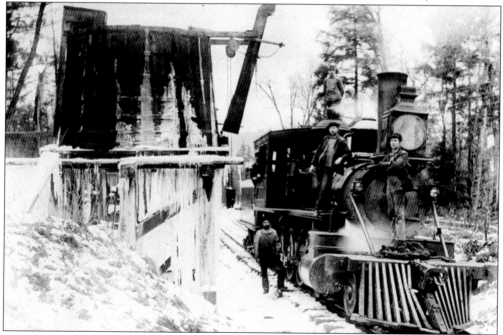

Railroading was a difficult and dirty job. It involved long hours and often days away from home. Train wrecks were a constant hazard of the job. The men worked inside of a rolling furnace. It was too hot in the summer and too cold in the winter. Winter involved additional problems. Water was essential to steam boilers. A trickle of water was left running to avoid freezing.

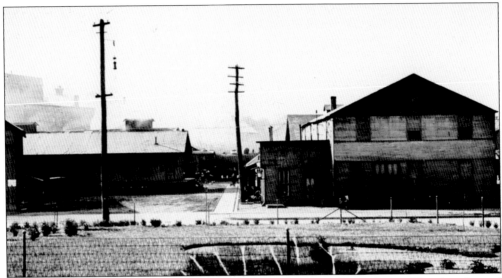

The Shawmut Railroad shops and freight station are shown on Depot Street. The shop burned on March 19, 1941. After this fire, the Shawmut Railroad purchased a modern building that had stood at the New York World's Fair. It was shipped to St. Marys and reassembled at the Junction (behind Stackpole Carbon Company). This building was eventually taken over by Stackpole Carbon Company and still stands in the Stackpole Complex.

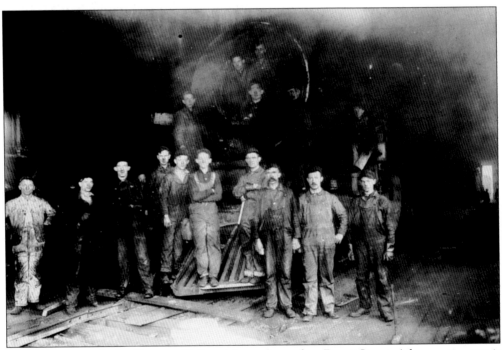

This is a view inside the Shawmut Railroad shops, located on Depot Street. A locomotive repair is underway by the workmen. This shop had the capability of complete locomotive rebuild on its equipment and employed many St. Marys workers. The shops burned in 1941 but were rebuilt. The Pennsylvania Railroad and the Pittsburg, Shawmut and Northern Railroad made St. Marys a bustling railroad town.

A Pennsylvania Railroad locomotive is shown passing by the south side of the Diamond. In the background is the Franklin Hotel on South St. Marys Street (later, the Boulevard). Note the horse-drawn hay wagon crossing South St. Marys Street. This photograph was taken from the upper floors of the St. Marys National Bank building. Notice how close houses were built to the railroad tracks.

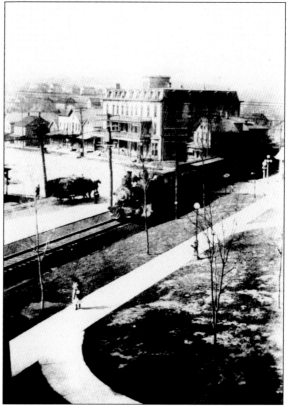

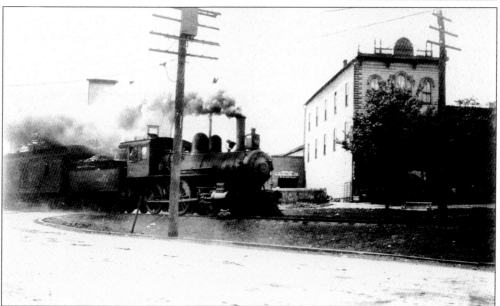

A Pennsylvania Railroad train chugs through St. Marys past the Hall and Kaul Hardware Store (later the St. Marys Boys Club). Obscured by smoke is the Vey Building, which was built so close to the tracks that the building shook when a train passed. During the steam era of the Pennsylvania Railroad, up to 25 trains a day passed through St. Marys.

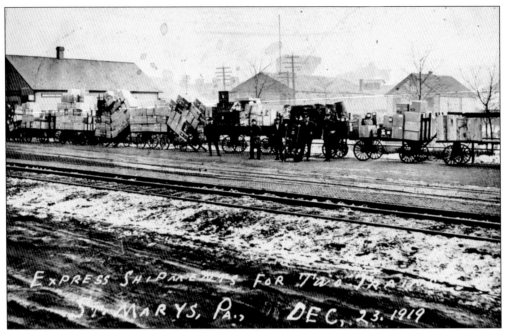

The Railway Express Agency station on South Erie Avenue is shown here on December 23, 1919. Note the large number of boxes and parcels waiting to be loaded onto the express train, most likely, many Christmas presents are among them. A shipment to Philadelphia arrived there the same day it left St. Marys. Automobiles arrived in St. Marys crated in boxcars, as did gasoline to run them.

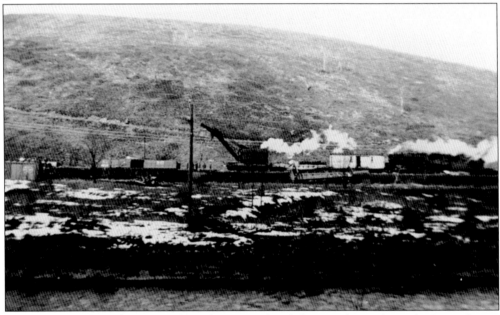

A steam-powered wrecker train is shown returning derailed cars to the tracks on the Pennsylvania Railroad between St. Marys and Ridgway. One Pennsy train loaded with corn wrecked near the same location, and bears came down to the tracks to eat the fermented corn. St. Marys residents went down to the Mohan Run crossing to watch the antics of the slightly inebriated bears.

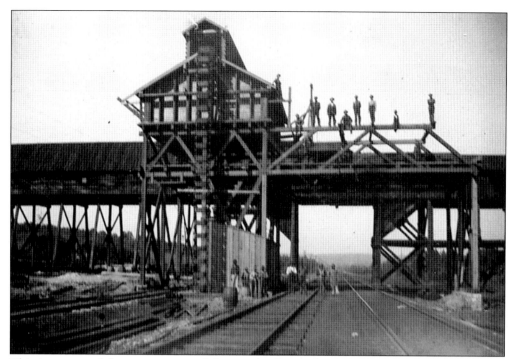

This is a scene of the construction of the wooden Pennsylvania Railroad coal tipple alongside Washington Street. Behind the construction, the chutes of the St. Marys Coal Company are already in place, running from Bunker Hill across Washington Street to the other hillside. Both structures burned in November 1906. The Pennsylvania Railroad replaced its tipple with a steel structure, while the St. Marys Coal Company chutes were not replaced.

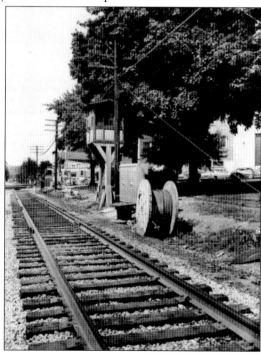

Pictured is the Gateman's Tower in downtown St. Marys. The gates were operated from this tower between 1919 and 1958, when the gates were automated and the tower demolished. The tower was necessitated by an accident in 1918, when a train killed three people in an automobile. Before the tower, the gates merely said "Stop, Look & Listen," with a red lantern burning kerosene at night as a warning.

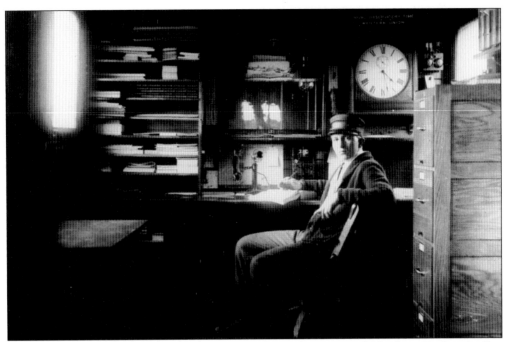

Nineteen-year-old William Foster mans the Pittsburg, Shawmut and Northern Railroad office in Byrnedale. Note that telephones have already replaced the telegraph. Under the desk are two hand lanterns used to signal passing trains. Trains ran on time; the clock reads "Naval Observatory Time Hourly By Western Union."

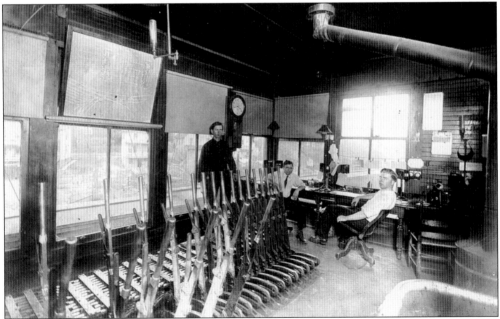

This is the interior of the Pennsylvania Railroad tower in St. Marys located on Curry Avenue. The levers were used to control the switches within the yard, allowing trains to move from one set of tracks to another. Washington Street is visible through the windows in the background. The Pennsylvania Railroad roundhouse was located nearby.

Three

INDUSTRY

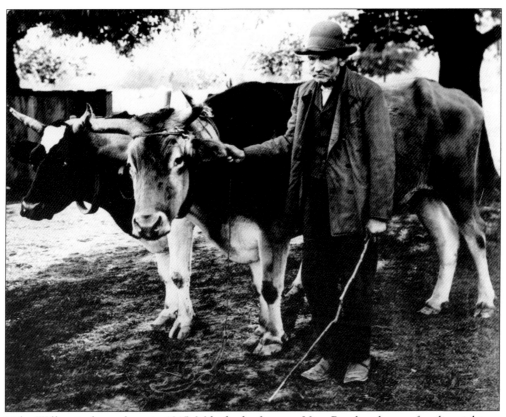

Mike Willert is shown here in 1915. Mike had a farm on Vine Road and was a familiar sight, as he would bring his farm wagon into town pulled by a pair of oxen. This is believed to be the last span of working oxen in the St. Marys area. Mike and his sister Mary "Opelt" were two of the more colorful characters inhabiting the St. Marys scene.

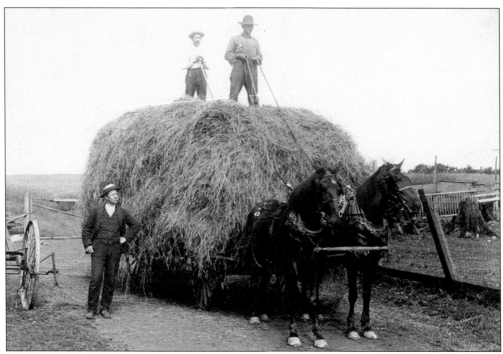

A hay wagon is pictured on the Weis and Walker farm in 1909 on North St. Marys Street. Henry Walker is standing beside the wagon. The German tradition of farming was the original occupation of a majority of St. Marys early residents, until they learned to adapt to utilizing the natural resources that the new land offered.

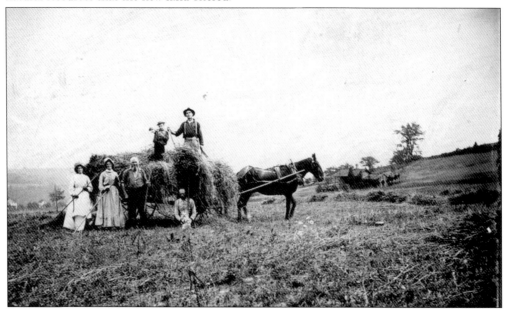

A haying party works Sisters Hill around 1910. This photograph shows homes on Maurus Street in the left background. Sugar Hill is above the homes across State Road. On the right is the clubhouse shanty of Fred Dippold, scene of many musical and drinking parties. Fred was a grave digger, coal miner, and local legend. The coal mine opening was beside his shack.

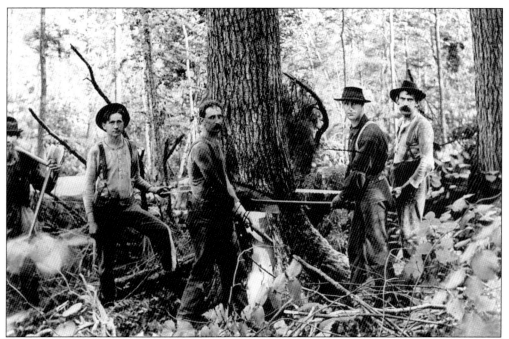

The most important early industry in St. Marys was lumbering. Lumberjacks, or woodhicks, worked six 12-hour days per week and used crosscut saws and double-bitted axes. When the first settlers arrived, it was said the forest was so dense that the first tree cut would not fall, but was supported by other trees.

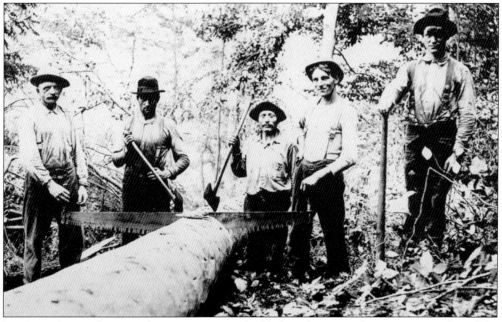

Lumberjacks are shown with a crosscut saw, double-bitted axes, and a peavey, a tool used for rolling logs. After the tree was cut, four-foot lengths were measured and a ring was cut around the tree with a double-bitted axe to prepare the log for bark peeling. Note the wide difference in ages on this crew.

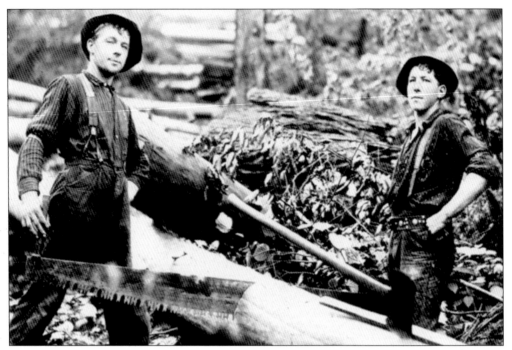

Pictured are crosscut sawyers at work. Lumbering brought more ethnic groups to the area. Some lumber camps were made up entirely of one ethnic group to prevent fighting in the camp. However, when the lumberjacks were paid and took the train into St. Marys to celebrate in the local drinking establishments, it was a different case altogether.

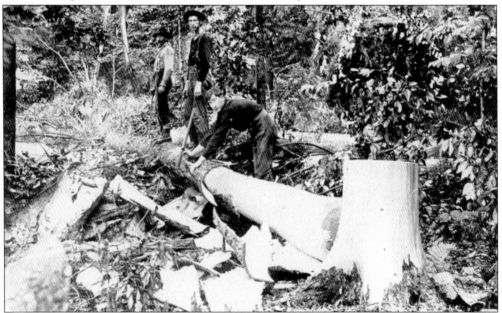

Bark peelers begin their chore. The bark of hemlock trees was very valuable for its tannic acid content, used in the tanning process to manufacture leather. A bumper used a double-bit axe to chop off small branches and then make a slit down the long end of the log. Then he used a tool called a bark spud to pry off the bark.

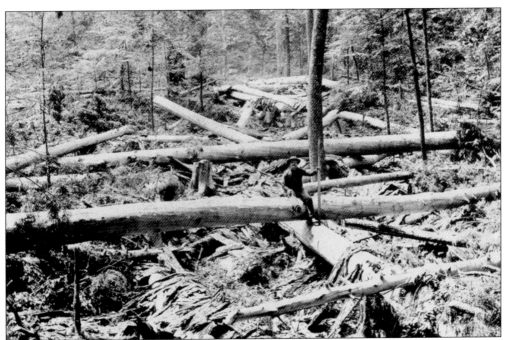

Here is a scene from when the big woods were being cut. A jumble of logs that have had their bark removed lie in the woods ready to be sawed into smaller lengths and hauled out. The lumberman shown is Alois Kerner, who was a timber cruiser. His job was to survey a tract of timber and estimate the amount of timber the tract would yield.

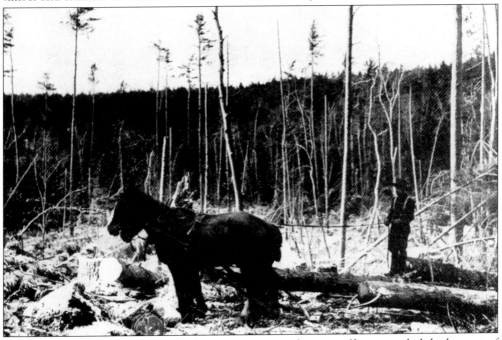

After the trees were cut into smaller logs, a swamper used a team of horses to skid the logs out of the forest to a railroad siding. Note that the drover stood on top of the logs and had to be very careful. It was a dangerous job, and many toes and fingers were smashed.

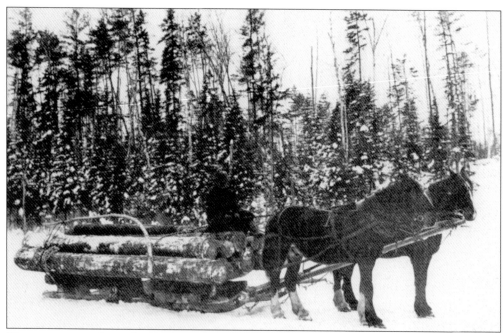

The teamsters welcomed a winter with sufficient snow, which allowed logs to be transported to the railroad siding by sled. Wooden chutes were also built to slide logs down the steep mountainsides to the skidder team. Sometimes the logs jumped the chutes and became flying missiles that were very dangerous.

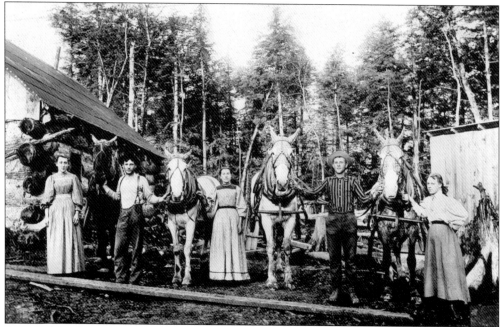

A typical lumber camp housed the woodhicks, teamsters, and female cooks. There were many such camps in the St. Marys area. This is the Cherry Lumber Camp in the Wildwood area showing off their horse teams. Most lumberjacks agreed that the food and accommodations at the camps were excellent. Occasionally entire lumber camps were lost due to forest fires.

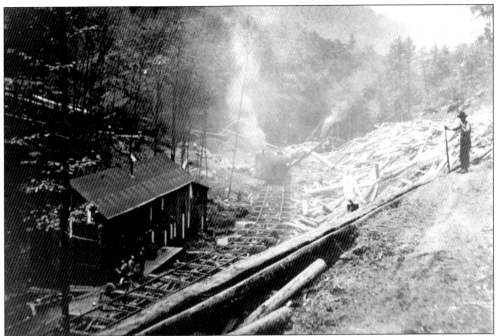

A steam-powered Barnhart loader is shown in operation at Trout Run. This machine was used to load logs onto railroad cars. The valleys were too narrow for dual tracks, so the loader moved from one car to another, loading the car behind it. A tong thrower threw a pair of tongs called a grab on the end of a cable to hook a log in the middle for loading.

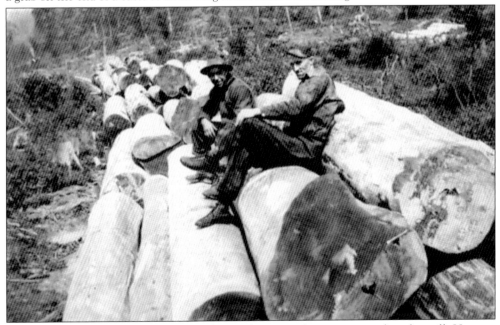

After logs were loaded onto the railroad cars, they were then transported to the mill. Here we see a pair of woodhicks riding the rails. The life of a lumberjack was very dangerous, as logs could shift without warning and crush limbs or worse. Note that another steam engine is heading into the picture. A typical log train was 28 cars long carrying about 50,000 board feet per train.

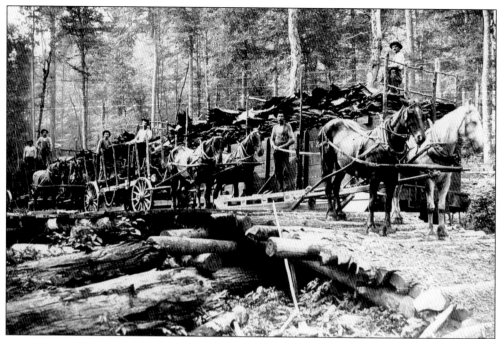

A bark train is being loaded for transportation to the tannery. Hemlock bark was utilized for its tannic acid content in the tanning of animal hides into leather. The bark was first loaded onto horse-drawn wagons, and then onto railroad cars. The entire region became a leader in the world for tanning leather, and eventually the bark was more valuable than the wood.

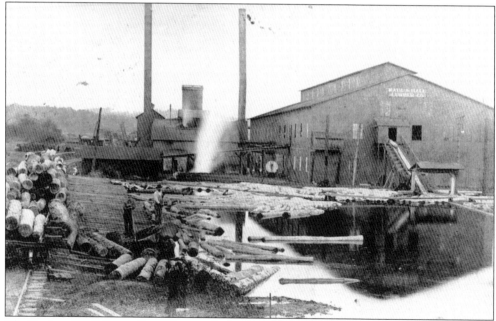

The Kaul and Hall Sawmill on Theresia Street, built in 1896 and burned in September 1924, was at one time one of the largest mills in Pennsylvania. Lumbermen used a pry bar to release the logs from the railroad cars. The logs then rolled down the incline and into the mill pond. Logs were floated to the jack slip where they were conveyed up and into the sawmill.

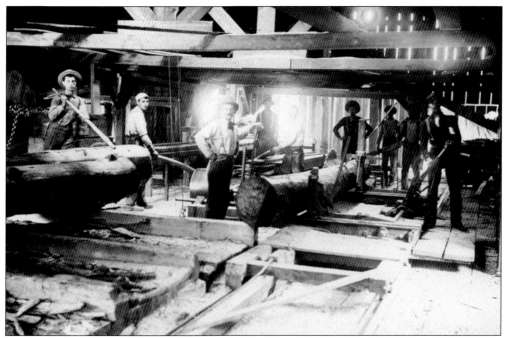

Here is an interior view of a typical sawmill. This is the Groll Sawmill around 1897, on Wolflick Creek. This mill was later operated by William Klausman. The head sawyer, Bill Klausman (wearing the tie), is shown third from left. Besides the big Hall and Kaul Sawmill, there were numerous small, family-owned sawmills in the area.

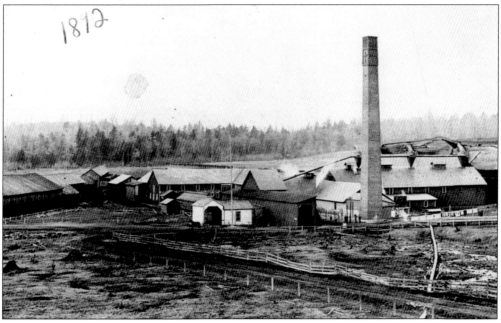

The St. Marys Tannery buildings are pictured in 1892. The tannery was one of the largest in the state and operated between 1884 and 1955. The brick smokestack had a cross design worked into the top in honor of one of the construction workers who died on the project and was too poor to afford a memorial.

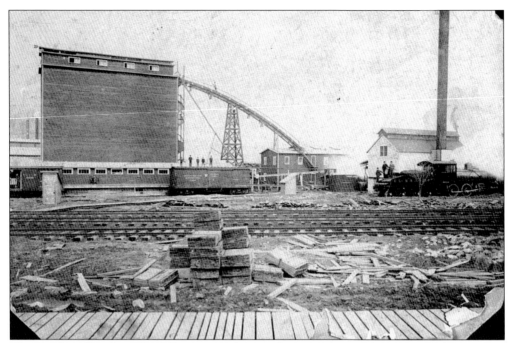

The St. Marys Kindling Wood Factory on Theresia Street was one of the many wood by-product businesses that depended on the timber industry. It was built in 1896 and burned in 1914. The locomotive shown is lettered for the Buffalo, St. Marys, and Southwestern Railroad, one of the predecessors of the Shawmut Railroad.

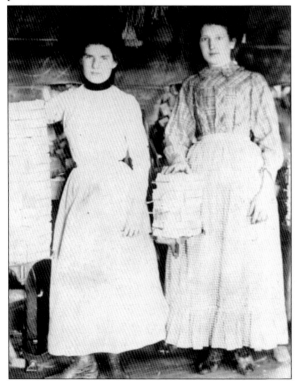

St. Marys Kindling Wood Factory workers are shown around 1900. This was one of the first factories in town to hire women. They wrapped small blocks of kindling wood into bundles for shipment to cities, where wood was scarce, and it was used to start cooking and heating fires. The women were paid 16¢ for every hundred bundles.

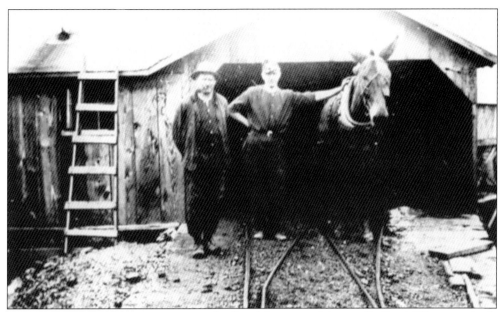

Here is a typical coal mine entrance at the Star Mine east of Averyville Road. There was little surface coal in the St. Marys area, but deep mining for coal became an important local industry before the coal seams became unproductive. The St. Marys Coal Company was a large operation, but there were also many small, family-owned or single miner operations.

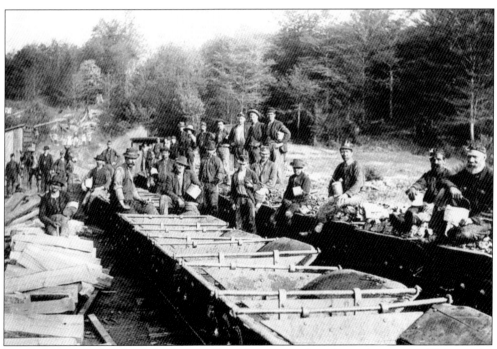

Coal miners with their lunch buckets and head lamps are riding the coal mine cars. This was the Hazel Dell Mine, whose entrance was located south of Brussells Street. The cars had no brakes and were slowed by spragging, or jamming a wood pin between the frame and wheel end. There were many coal mines in the St. Marys area.

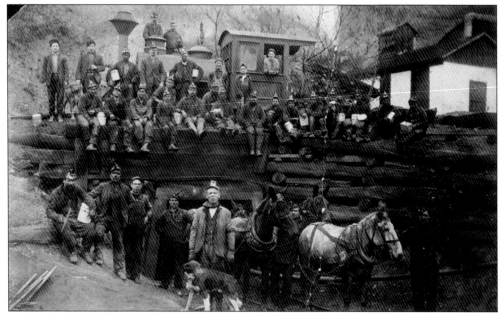

Here is a typical Shawmut coal mine around the early 20th century. Miners with lunch buckets and lamps mounted on their hats surround the mine entrance. Note the multiple types of locomotion. Both horses and trains were used. The Drummond Mine was located southwest of St. Marys. A Shawmut passenger train took miners daily from St. Marys to the Brockway area. (Courtesy Bauer Collection.)

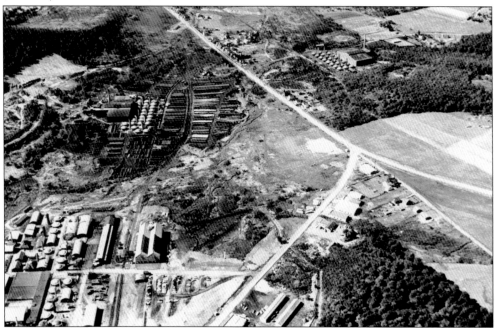

An aerial view of the industrial east end of St. Marys shows Stackpole Carbon Company's Benzinger Township Plant, lower left, on the site of the old Pennsylvania Fireproofing Company. Above that is the St. Marys Sewer Pipe Company with clay digging pits behind it on the left. In the upper center is the Speer Carbon Company, and in the right center is the St. Marys Clay Products Company.

St. Marys Sewer Pipe Company was organized in 1901 by Andrew Kaul and J. K. P. Hall. This wooden building burned in 1926 and was immediately replaced by a brick building. In 1905, it was supposedly the largest sewer pipe plant in the world. Their product can be seen stacked at the lower right.

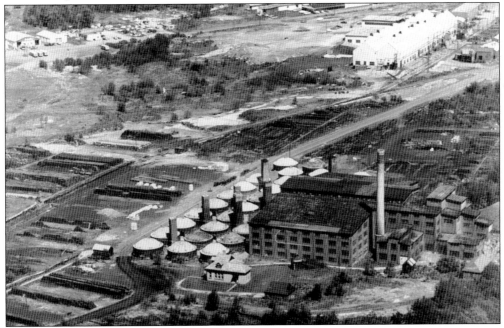

The new brick building replaced the original wooden structure at St. Marys Sewer Pipe Company off Theresia Street. Note the circular beehive ovens used to bake clay products. This was the first of the four major refractory operations in St. Marys and the last to go out of business.

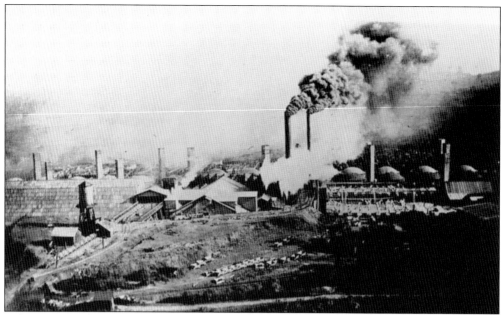

The Pennsylvania Fireproofing Company, founded in 1901, generated a lot of smoke. They made building blocks that were fireproof, durable, and good insulation. The company declined when cinder blocks came on the market. Many homes in the St. Marys area were built of fireproof blocks. In 1940, Stackpole Carbon Company took over the site and used the beehive kilns to bake carbon.

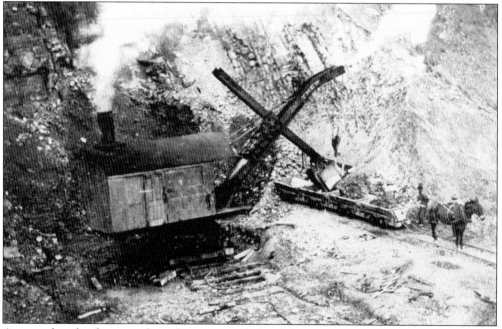

A steam shovel is shown working the strip mine behind the Pennsylvania Fireproofing Company. Clay was dug and loaded onto mine cars on rails to be hauled by mules to the factory where the product was shaped and then baked in kilns. The Shawmut Railroad ran behind the plant. Hoboes used to hang out by the kilns for warmth on cold nights.

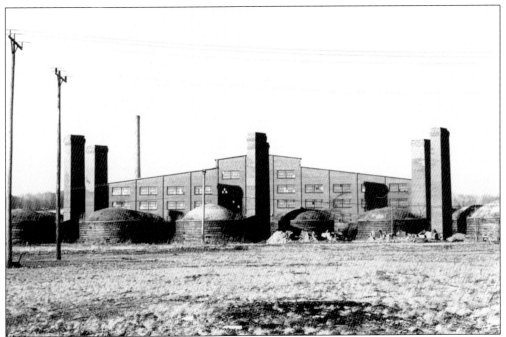

The St. Marys Clay Products Company was located across Brussells Street from the St. Marys Sewer Pipe Company. They both utilized the same type of beehive kilns for baking clay products. This site was earlier used by the Chemical Works Factory. Today the building is occupied by the Penn Pallet Company.

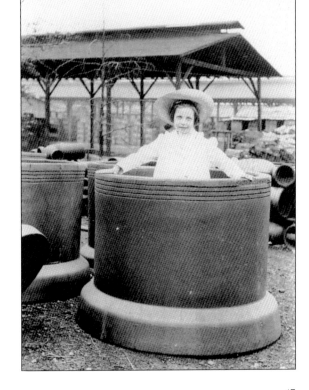

This little girl is surrounded by one of St. Marys's signature products: sewer pipe made from local clay. Four different clay product factories operated in St. Marys. Three of these industries were clustered at the east end of town. Rows and rows of sewer pipe waiting to be shipped was a common sight along Brussells Street.

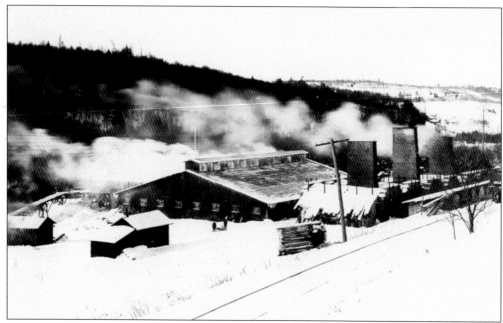

The Elk Fire Brick Company, located on State Road in 1905, manufactured fire-resistant bricks. This company also had plants in Daguscahonda and Renovo. The hill behind the plant is where the fire-resistant clay was mined. There was much clay in the St. Marys area, and clay product industries flourished. The plant closed in 1956.

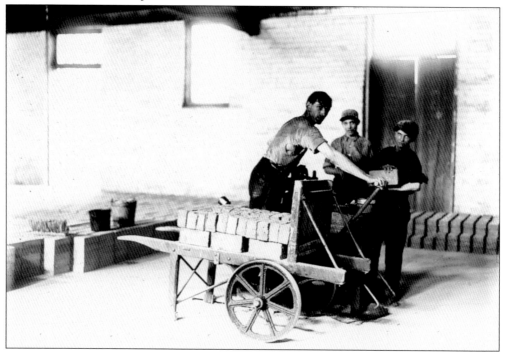

Elk Fire Brick Company workers are loading bricks onto a handcart at the plant on State Road. This operation made fire-resistant brick to line fireboxes and furnaces. Clay was mined from the hills on both sides of the plant. Note the young age of some of the workers.

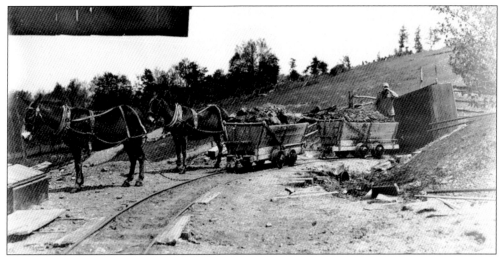

The Sugar Hill Clay Mine was located on Muenster Road near the Gregory farm. Mules are pictured pulling the mine cars loaded with clay-bearing rock out of the mine entrance on a narrow-gauge railway. This mine is located on the hill across State Road from the factory. It closed in 1949.

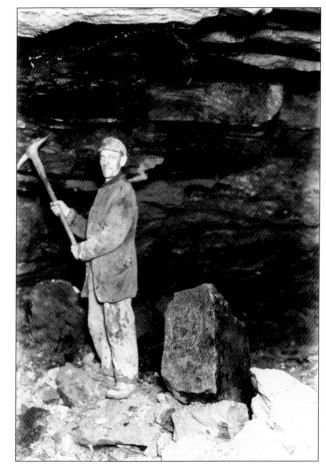

John Grattel is digging fire clay in the Sugar Hill Clay Mine in 1916. The clay was then transported down the hill to the Elk Fire Brick factory on State Road. Underground mining was always a dangerous occupation. Note the large rock that has evidently fallen from the roof of the mine.

This is a view of the Johnsonburg Road showing the hospital curve being built. Note the road-grading equipment building the new highway. In the background can be seen the clay diggings that were located on Sisters Hill, which was part of the Elk Fire Brick Company. The mine had an overhead tramway to transport clay to its facility on State Road.

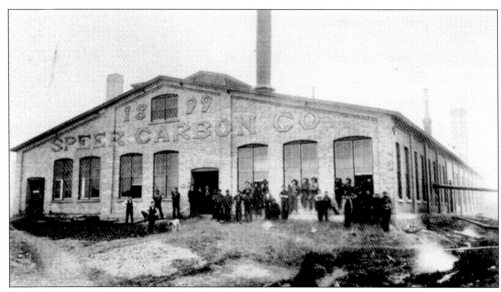

Speer Carbon Company was founded in 1899 by Andrew Kaul. This is the original building. Andrew Kaul brought in Jack Speer, who knew the carbon business, to keep St. Marys thriving after the extractive industries eventually depleted the area's natural resources. Speer Carbon Company eventually became Airco-Speer Carbon and later Carbon Graphite and SGL Carbon.

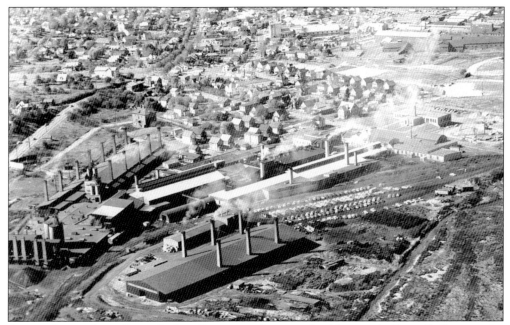

An aerial view shows Speer Carbon Company after considerable growth. Brussells Street is the curving roadway in the left of the photograph. The large structure on Theresia Street is Andrew Kaul's home. The tall rectangular building at the top center was the St. Marys Brewery (now Pure Carbon Company in this photograph). At the upper right, the St. Marys Tannery buildings and Stackpole Carbon Company can be seen.

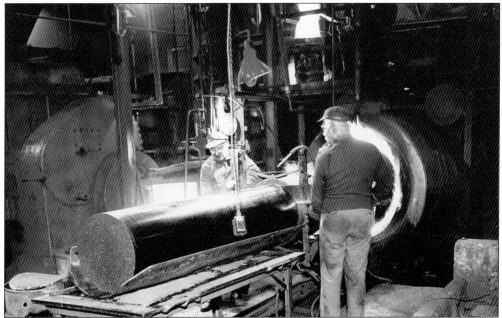

Here is an interior view of Speer Carbon Company and one of the products they produced. The photograph shows a graphite electrode being extruded on a large press. The "green" rod then had to be baked, impregnated with pitch, and graphitized to make it usable for the steel industry in melting steel scrap.

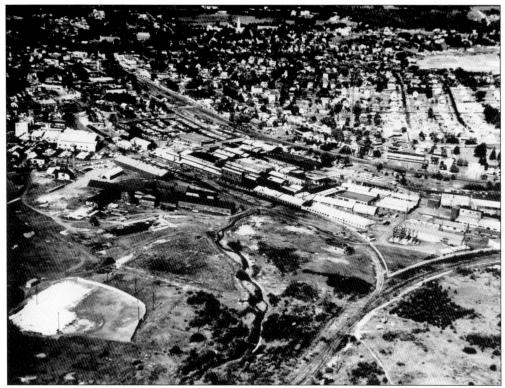

An aerial view of Stackpole Carbon Company shows the downtown in the background. At the middle left is Pure Carbon Company, and slightly below that are the tannery buildings. At the top right of the photograph are the baseball diamonds of Memorial Park. Note St. Marys Church in the top center.

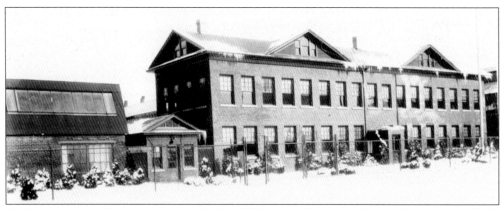

Stackpole Carbon Company was founded in 1906 as the Stackpole Battery Company by H. C. Stackpole and his father-in-law J. K. P. Hall. Stackpole Carbon Company would become the leading employer in Elk County for many years before winding down operations in the 1980s. Today the Stackpole Complex is utilized by several businesses.

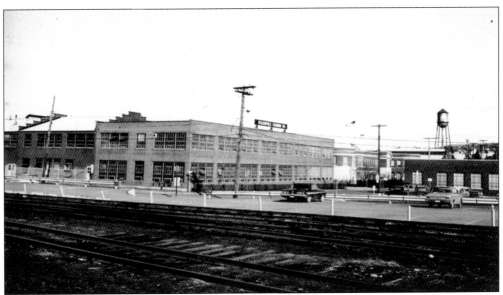

Here is a later view of Stackpole Carbon Company after some remodeling of the buildings. The plant entrance is in the right center and across the street is the company cafeteria. The rectangular building, under the sign, housed the resistor and automotive carbon brush departments. In the background, the water tank for the tannery can be seen. Stackpole Carbon Company eventually purchased the tannery buildings.

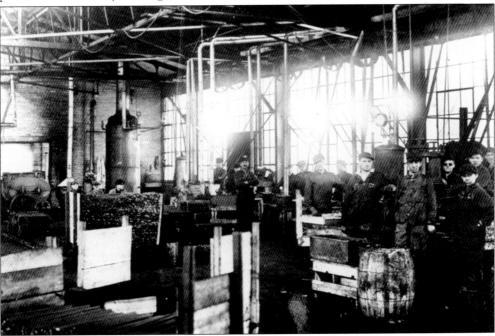

Here is an interior view of a typical carbon operation. The largest of the carbon factories, Stackpole Carbon Company started as a battery maker, eventually manufacturing many diverse products, concentrating on carbon, graphite, ferrites, and electronic parts. Besides their two locations in St. Marys, the firm eventually included plants in several nearby communities and other states.

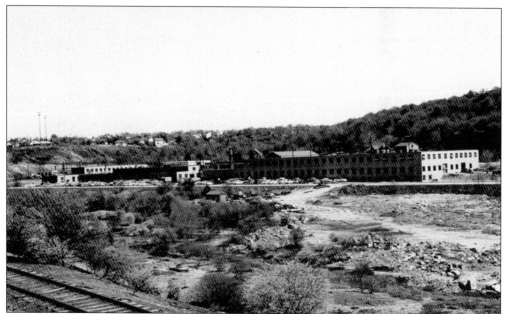

Keystone Carbon Company is located on State Road. The buildings of Keystone Carbon Company merge into those of St. Marys Carbon Company at the extreme left. Above St. Marys Carbon Company is Berwind Heights. Note the light standards at Berwind Park baseball/football field. Above and to the right is Sugar Hill. Elk Creek can be seen flowing through the foreground, and the Pennsy tracks are also visible.

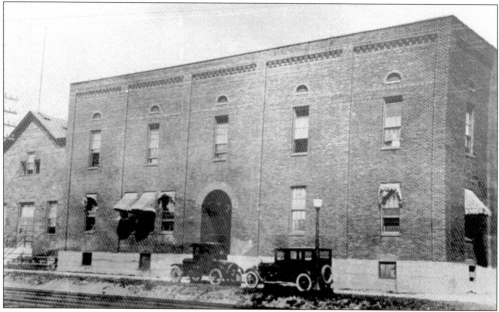

The Novelty Incandescent Lamp Company (NILCO) was located on Erie Avenue. It later became the Sylvania Company. When Sylvania opened its new plant on Washington Street, its old buildings were donated to the borough in 1955. The building on the left became the home of the Crystal Fire Department. The building on the right became the municipal building, housing the borough council, police department, youth center, and historical society.

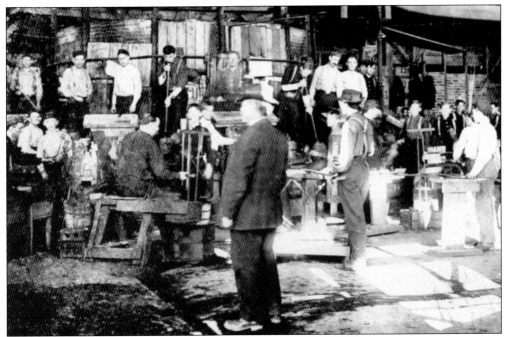

An interior view of the Pierce Glass Works on Fourth Street is pictured. Note the glassblowers at work in the background and the gentleman in the suit and bowler hat in the foreground, possibly the owner or foreman. This building burned in 1911. This site was later occupied by the St. Marys Builders and Manufacturers Supply Company and later Goetz Hardware and Feed Store, owned by Raphael Goetz.

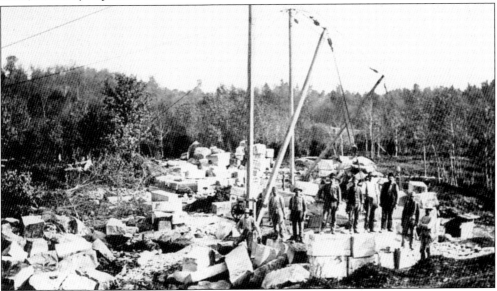

The Schlimm Stone Quarry, on upper Silver Creek, was one of several local sandstone operations. Sandstone was utilized in the building of local structures, including churches, bridges, and foundations. Note the primitive hoisting mechanisms used to move the heavy stone, which was then loaded and hauled to construction sites by teamsters. Today there is little evidence of these quarries, as they used surface cutting, which quickly became overgrown.

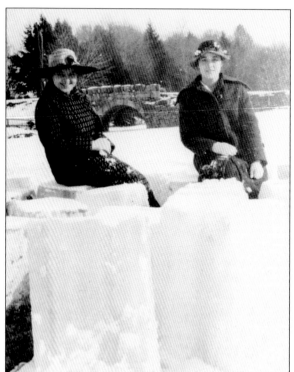

Another important industry in the days before mechanical refrigeration was ice cutting. In this photograph, the Friedl sisters pose on Zwack's Pond upon some blocks of ice ready for hauling. Note in the background the bridge that carries South St. Marys Road across Iron Run. This bridge was covered and the road considerably elevated when the Million Dollar Highway was built.

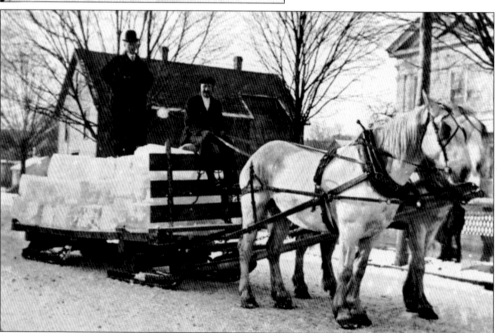

The ice-delivery sleigh was a common sight in St. Marys before the days of refrigeration. Ice was delivered from several area ponds, including Zwack's, upper Brewery Run (near present Memorial Park), and upper Center Street. Many homes had beautifully ornate iceboxes. The only care needed was to empty the drip tray. The sudden shock of ice-cold water on bare feet meant this duty had been neglected.

56

Four

COMMUNITY

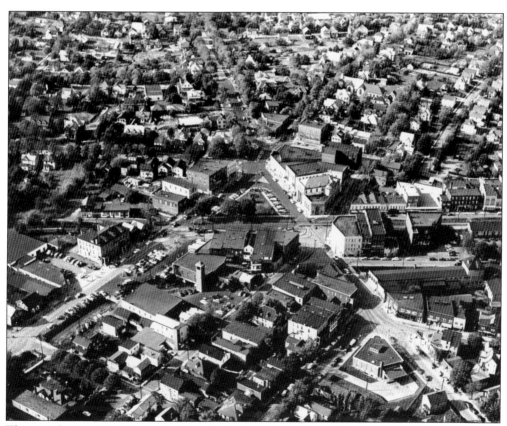

This aerial view of St. Marys, looking north, shows the Diamond, prominent in the very center of the photograph. Railroad Street is the base of the Diamond, and Erie Avenue continues east (right in the photograph). At the lower right, the large polygon shaped building is the post office at the intersection of South Michael, Chestnut, and Brussells Streets. This photograph dates from 1951.

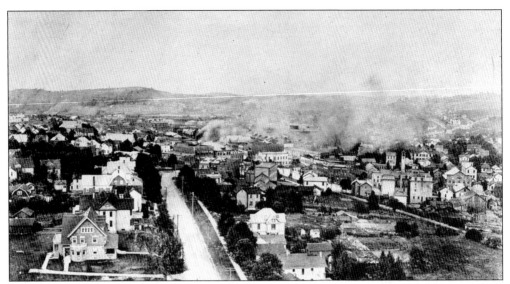

This is a view from the Sacred Heart Church steeple looking east down Center Street. Note the smoke from a steam locomotive passing through St. Marys. At the end of Center Street and to the right is the downtown. The stately mansion on the left side of Center Street (closest in the photograph) is the residence of George Simons (currently the American Legion).

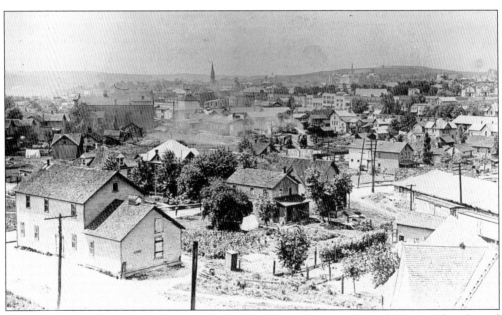

This view was taken from the top of the St. Marys Brewery. Sacred Heart Church and St. Marys Church steeples can be seen on the horizon. Between the steeples and below them is Erie Avenue. Note the trains puffing down the tracks in the center of the photograph. The building in the left foreground is the cheese factory. The large building (center left) is the Temple Theater.

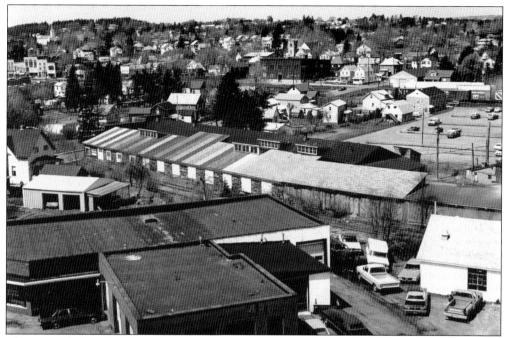

This is another view from the top of the St. Marys Brewery (now Pure Carbon Company). This view was captured slightly to the right of the last one. St. Marys Church steeple is in the upper left with Erie Avenue below it. Note the large building in the foreground, the St. Marys Builders and Manufacturers Supply Company with its long shed displaying on its roof the different styles of shingles that they sell.

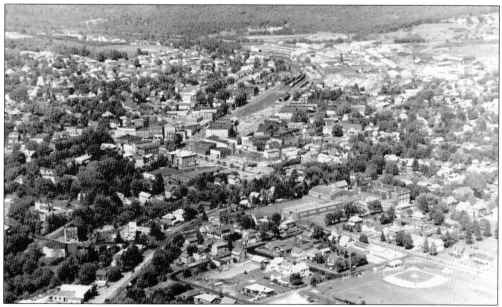

Shown here is an aerial view of St. Marys looking toward the northeast. Berwind Park baseball diamond is in the lower right, and above that is the South St. Marys Street School. The downtown is in the very center of the photograph, and the Stackpole Carbon Company Complex is in the upper right with railroad yards on its left and the tannery buildings to the right.

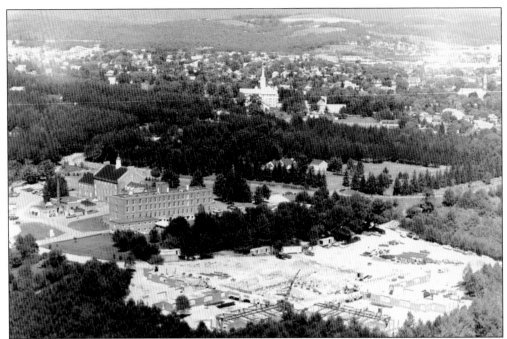

An aerial view of the west end of St. Marys shows the Extended Care facility, now known as Pinecrest Manor, under construction in 1970, adjacent to the Andrew Kaul Memorial Hospital. The convent and St. Marys Church steeple are in the upper center, and Sacred Heart Church is in the right center. Today the Elk Regional Health Center includes many more new buildings.

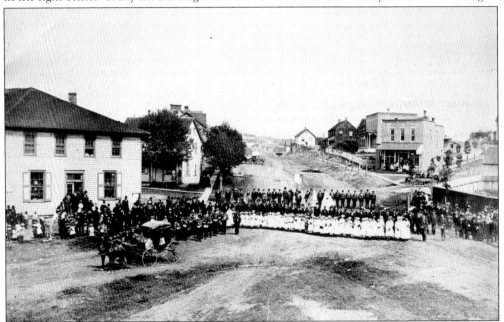

Seen here is a view of the Diamond looking north at the Memorial Day parade in 1883. The brick building with the awning is John E. Weidenboerner's store, and behind it is his residence (today known as the Proctor House). Note the wooden stockade fence on the right, where livestock were kept prior to butchering. This site is now occupied by the movie theater.

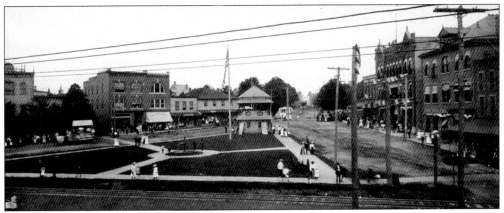

This is a view of the Diamond looking north, up North Michael Street. The bandstand is still in place at the north end of the Diamond, and an oval sidewalk contains an ornate iron water fountain. At the southeast corner of the Diamond is a cannon with stacked cannonballs. The event is the 1906 Old Home Week Celebration.

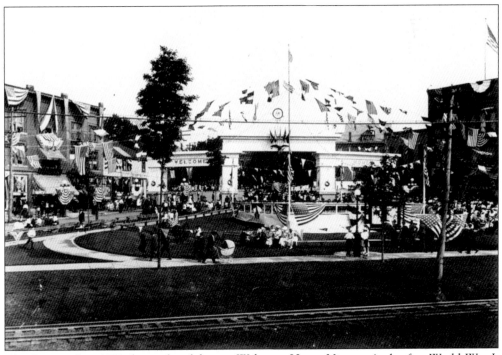

The Diamond in 1919 shows the elaborate Welcome Home Victory Arch after World War I. There were numerous events scheduled for this celebration, including two large parades, field events, boxing matches, and ball games. In the foreground, a large platform for speeches, concerts, and presentations of medals to veterans can be seen. Special Shawmut Railroad excursion trains were chartered to bring spectators from neighboring towns.

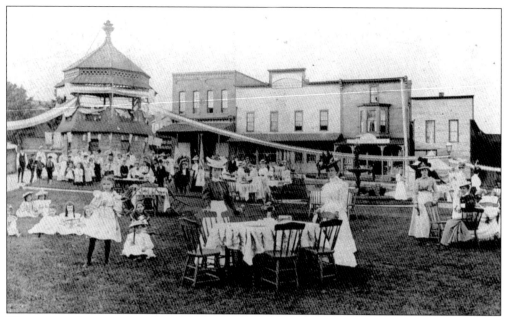

The view is the east side of the Diamond. The event is an ice-cream social about 1905. The buildings in the background were all eventually torn down and replaced. On the left is the bandstand whose base was the gas regulator for St. Marys. The band often preferred to play on the grass, as the bandstand was usually filled with fumes.

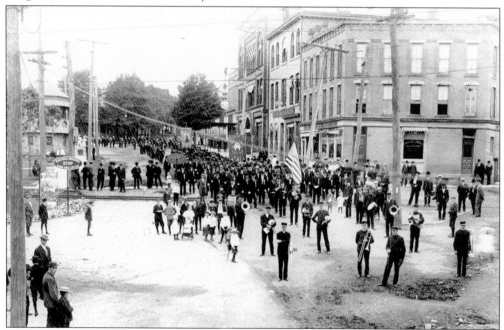

This photograph of the bank corner shows a parade coming down North Michael Street. Proceeding back up North Michael Street, the buildings are the Kaul and Hall Lumber Company office, the St. Marys National Bank (with the upstairs housing the Pittsburg, Shawmut and Northern Railroad offices and Sen. J. K. P. Hall's office), the Hall and Kaul Department Store, and the last building was originally the Coryell and Russ store.

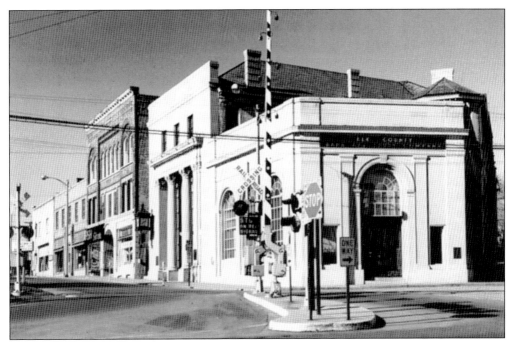

The bank corner, as seen in 1969, after the corner Wilhelm Building had been replaced by the St. Marys Trust Company building, is seen here. The next building up the street has a new facade with columns and is the St. Marys National Bank. Note the grand clock attached to this building. The next two buildings housed Smith Brothers Department Store and the final building is the St. Marys Movie Theater.

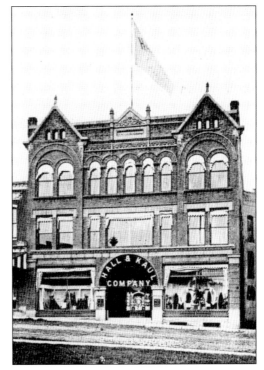

Shown is the Hall and Kaul Department Store on the east side of the Diamond before the overhanging cornices had been removed for safety purposes. Later this building became the Smith Brothers Department Store and was torn down in 1970 to make way for the new bank parking lot.

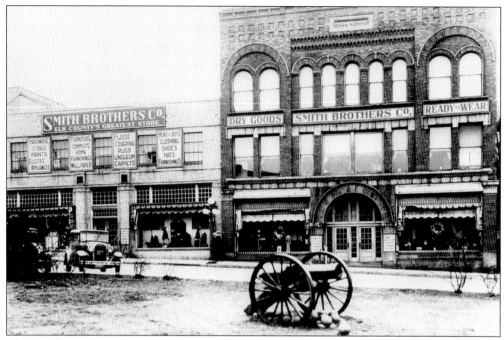

The Smith Brothers Department Store on the east side of the Diamond was in the old Hall and Kaul building (right) and the old Coryell and Russ company store (left). The building on the right was eventually torn down when the new bank building was erected in 1970, to become the bank parking lot. The department stores on this site were some of the largest in the area.

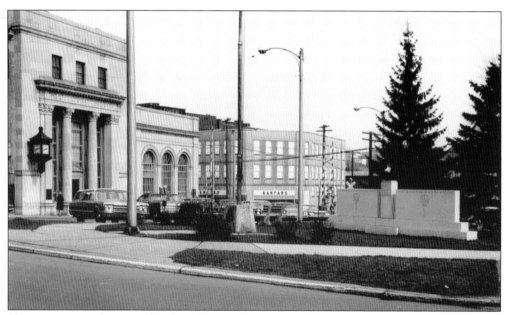

Here is a view of the east side of the Diamond in 1967. The Memorial Flame honoring veterans was added in 1966. The buildings from left to right are the St. Marys National Bank, with columns and a grand clock hanging from the wall, the St. Marys Trust Company, and across Erie Avenue to the right, the Kantar's Department Store, which is now known as the Marienstadt Building.

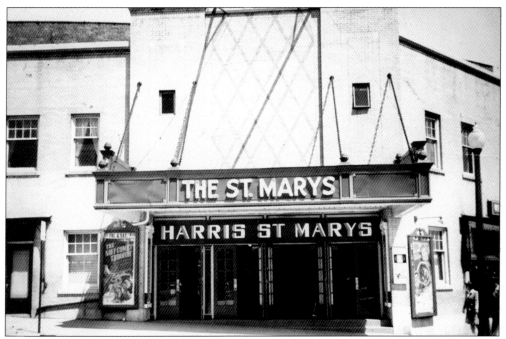

The St. Marys Movie Theater was built in 1928 as part of the Harris chain. On the right is the Western Union Office and on the left was often a barbershop. The film playing at the time was *The Navy Comes Through* from 1942. The building was elegantly decorated inside and is still being used as a movie theater.

The Elks Lodge is on the corner of Washington and Lafayette Streets. This large, ornate, red-brick building is home to the Elks Club. Large elk heads mounted on the facade of the building have light bulbs on the tips of their antlers. During the influenza epidemic of 1918, the Elks building was used as a temporary hospital, confirming the community's need for a full-service hospital. (Courtesy Dennis McGeehan.)

Shown here is the Knights of Columbus building, located at the corner of North St. Marys and Washington Streets, as it was originally built. It was known as the Nissel building when completed in 1901. Gutted by fire in February 1938, it was rebuilt without the upper half story. The first floor housed a beautiful banquet hall called the Knotty Pine Room. The third floor held a dance floor.

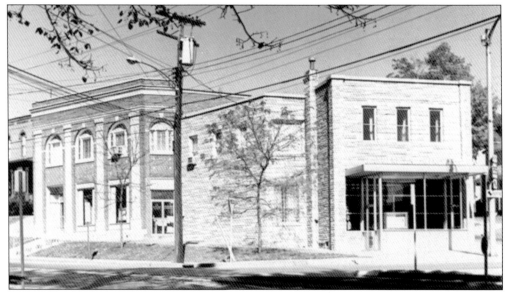

Pictured is the corner of North Michael and North St. Marys Streets. After the fire of 1880, John Weidenboerner rebuilt with brick. On the corner, in this photograph from 1971, is Weidenboerner's store, later the Farmers and Merchants Bank. Weidenboerner's residence (later renamed the Proctor House) is visible on the left, and the building in the middle was the post office and later the State Store.

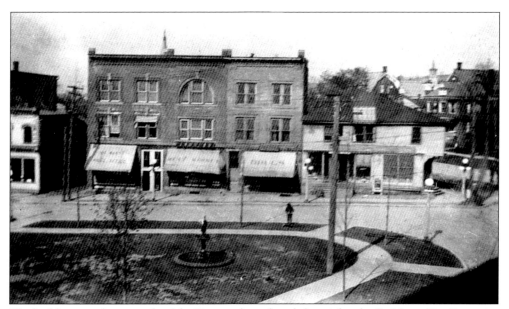

The buildings on the west side of the Diamond are, from left to right, the St. Marys Gas Company office, the Koch Building (with the ground floor occupied by St. Marys Post Office and Lion Meat Market), the Spafford Building (the ground floor occupied by Central Drug Store), and the first Dimitri Building (this upper floor with skylight occupied by Thomas Ewing's Photo Studio). Note St. Marys Church steeple in the upper right.

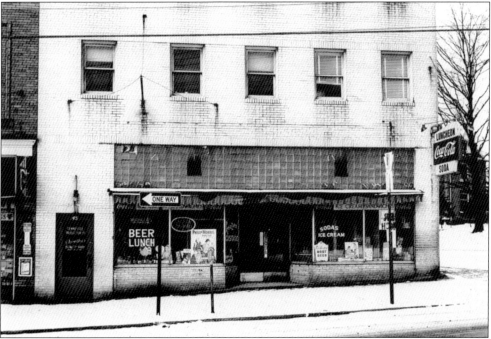

The corner of Center Street and South St. Marys Street on the west side of the Diamond is seen here occupied by the second Dimitri Building, a three-story, blonde-brick structure. The first wooden Dimitri Building on the same site burned in 1936. The ground floor in this 1952 photograph is Lucanick's Restaurant and Soda Fountain.

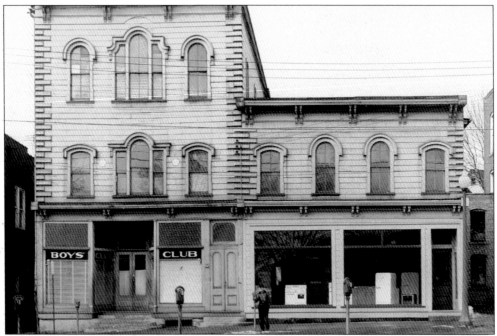

In 1873, J. K. P. Hall opened the Hall and Kaul Company Store with an amusement hall upstairs that included concerts and home talent shows. In 1924, this building became the St. Marys Boys Club. In 1952, the right half of this building was replaced with the boys club gymnasium. In 1977, the old boys club (left) was replaced by a new building attached to the gymnasium.

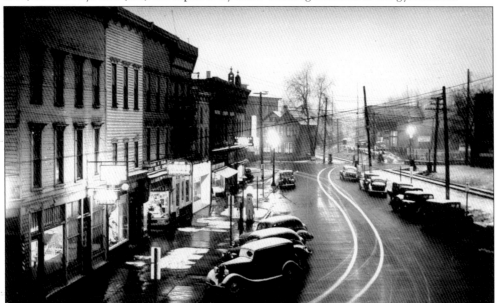

Railroad Street is on the south end of the Diamond. Note traffic traveling in both directions then. Occupants of Railroad Street are, from left to right, the Nicklas Barber Shop, Schieler's Tavern and Restaurant, a shoe store, Widmann and Teah Drug Store, Mike Wolf's Gas Station (note the curbside pump), Gorman's Dairy Store, Eddie Lion's Mercantile, and Luhr Drug, also second-floor tenants Dr. C. R. Hayes, Optometrist, and Dr. Howard Keebler.

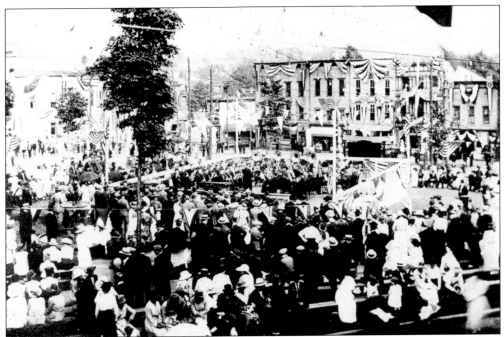

This event is a band concert on the Diamond on a large temporary platform during the Welcome Home Celebration at the end of World War I in 1919. Note that bleachers have been set up in front of the platform, which also hosted speeches and other events. On the left, the iron water fountain is still in place. In the right background are the businesses along Railroad Street.

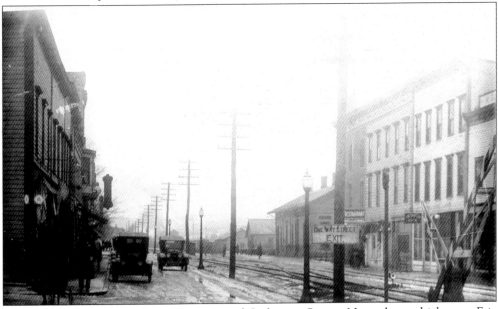

Pictured is the corner of Erie Avenue and Lafayette Street. Note that vehicles on Erie Avenue went the other direction at the time. On South Erie Avenue from left to right are the Pennsylvania Railroad freight station; the Railway Express Agency station; the Pennsylvania Railroad passenger station; the City Hotel, which burned in 1925 and was replaced by the Moose building; and a café that also housed billiards, movies, and Vaudeville performances.

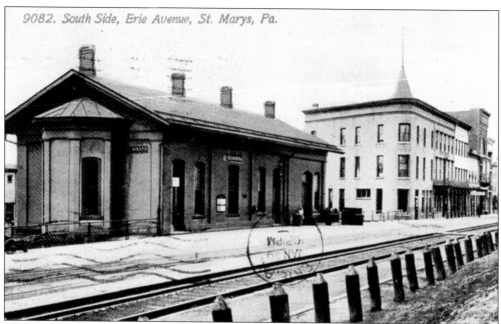

The south side of Erie Avenue is shown here with the Pennsylvania Railroad passenger station; the City Hotel with its conical top; and the tall building down the street, which is the second Silman building constructed of brick. When the City Hotel burned in 1925, the Loyal Order of Moose erected its building on that site.

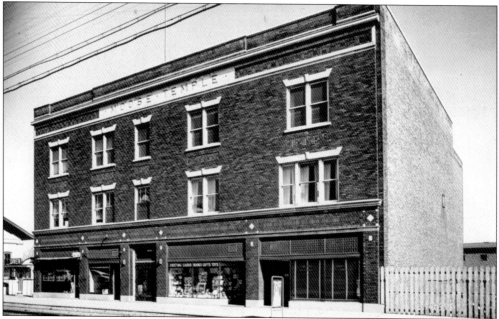

A view of the first Moose building in the 1940s is pictured. On the left, the corner of the Pennsylvania Railroad station is visible. Beside it is a dining car restaurant that occupied the spot for many years. The ground floor occupants of the Moose building were, from left to right, the Nicklas Barber Shop, the Water Company office, the Moose Club entrance, Al Marsh's Variety Store, and the borough offices.

This is a view of Erie Avenue as seen from the top of the Family Theater. The buildings from left to right are the Pennsylvania Railroad passenger station, the Club Diner, the Loyal Order of Moose Lodge, the tall building is the second Silman building, and on the corner is Kantar's Department Store. Across South St. Marys Street is the Franklin Hotel.

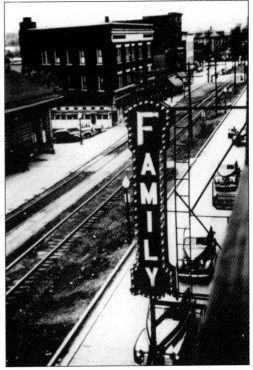

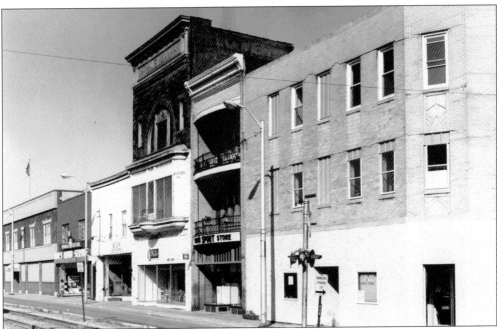

Here is a more recent picture of the south side of Erie Avenue. From left to right are the new Moose building, Hoy's Appliance Store, BJ's Ladies Apparel, the second Silman building, the Arcade building (Smith's Sport Store), and the Kantar's Department Store building, currently known as the Marienstadt Building housing the St. Marys Community Education Council. (Courtesy Ray Beimel.)

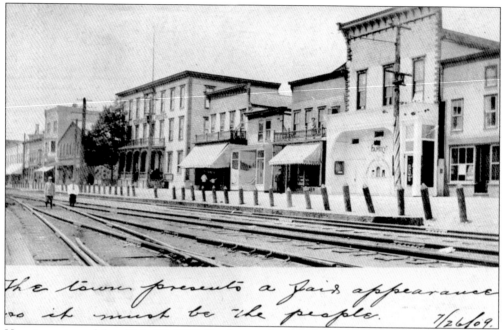

The town presents a fair appearance so it must be the people. 7/26/09.

Here is a postcard dated July 26, 1909. On the north side of Erie Avenue, the tall building with the portico is the Family Theater. All buildings on the right burned in the great fire of 1910. The large building farther down the street is the Commercial Hotel, which was spared. This postcard view's message reads, "the town presents a fair appearance, so it must be the people."

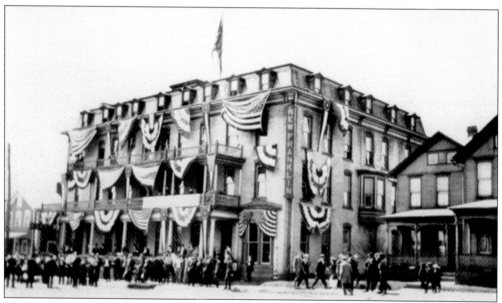

The Franklin Hotel, located on the west side of South St. Marys Street, was the headquarters for the Welcome Home Celebration in August 1919 at the end of World War I. In the photograph, a band performs in the street. Bands also performed from the front porch of the hotel. Three years later, a fire destroyed the fourth floor of the Franklin Hotel. The entire building was destroyed by fire in 2000.

The Wittman Building, on the east side of South St. Marys Street, is shown after a winter ice storm, as seen from the top of the Franklin Hotel. The Wittman family sold Ford automobiles here. Later the building became the Acme Market and later Valentine's Furniture Store. The building was replaced by a new structure that was the Bavarian Restaurant (currently Gunners).

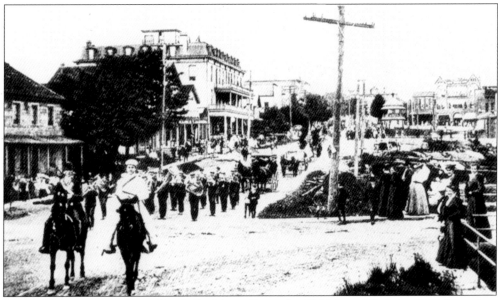

Pictured here is a parade on South St. Marys Street for Old Home Week in 1906. Note that Elk Creek is not covered yet. On the left is the 1845 Building, the first stone building in town. Prominent farther up the street is the Franklin Hotel. The bandstand can be seen on the Diamond and the Hall and Kaul Department Store with its original facade can also be seen.

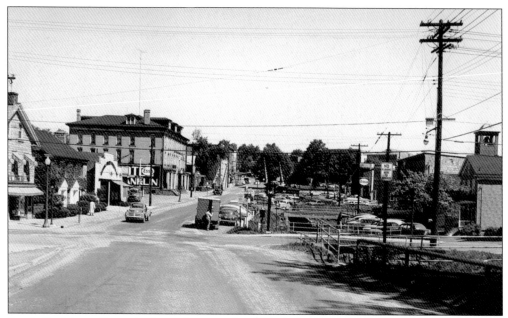

South St. Marys Street is shown here in the 1950s before Elk Creek was covered to become the Boulevard. The buildings on the left side of the street are, from left to right, the first two stone buildings in town (the Red and White grocery store and the ivy-covered 1845 Building), National Molded Products (the former City Garage), and the Franklin Hotel. Mill Street crosses the street in the center of the photograph.

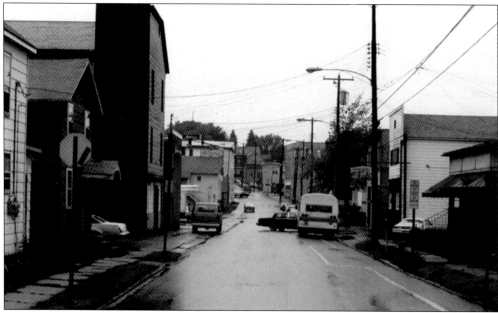

This is the entire length of Market Street, the busiest little street in St. Marys, where many bars and restaurants operated. The large structure in the center with the brick tower is the Elk Candy Company. The white building on the right is the Marquette Café and Tavern. The original St. Marys Town Hall stood in the parking lot between Market Street and the Boulevard.

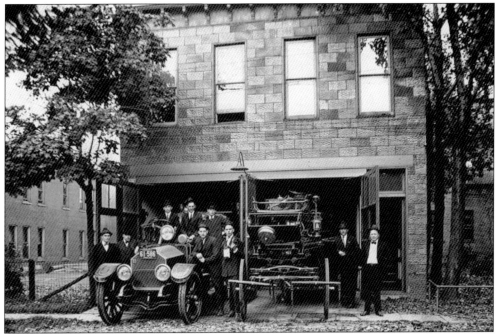

In this photograph, the Crystal Fire Department Hall is housed on Market Street. On the left is the 1917 la France, the first motorized fire truck in St. Marys. On the right is the older, horse-drawn ladder truck. Fire chief Frank Robacker is at the right. This building later became Diamond Dick's Bar and Grill and is presently Dino's Bar. This building is made from Pennsylvania Fireproofing Company blocks.

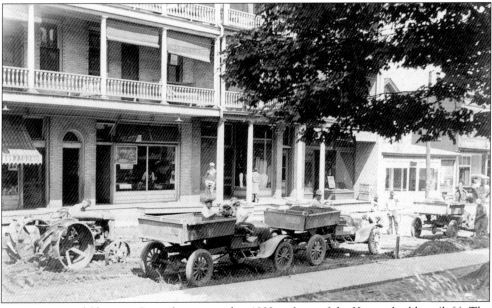

Here is a view of Chestnut Street being paved in 1922 in front of the Koenig building (left). The ground floor of this building at various times included the Globe Grocery Store, City Pharmacy, PFL Club, Daniel's Barber Shop, Rogan Furniture Store, Zelt Music Store, Kronenwetter Ladies Garment Store, Mike Herbst Tailor Shop, and a cigar factory, among others.

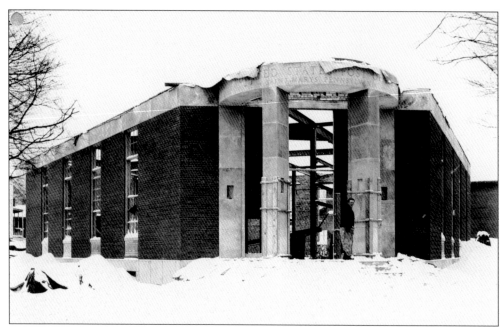

St. Marys Post Office was built in 1941 at the intersection of Chestnut, South Michael, and Brussells Streets (on the site of the original Township School No. 1). Ignatius Garner was St. Marys first postmaster, operating from his home on the corner of South St. Marys Street and State Road. The post office has also been located on the Diamond and North Michael Street.

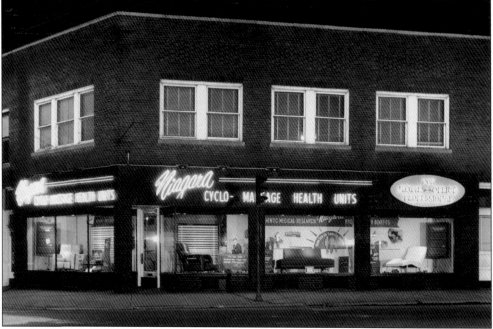

Here one sees the corner of South Michael and Brussells Streets, at the time being used for the Niagara Cyclo Massage Store. The building has also been occupied by Fleming Brothers Electrical Supply, Home Telephone Company, and Northwest Savings Bank. The entire block is scheduled for demolition in 2006 to make way for new development.

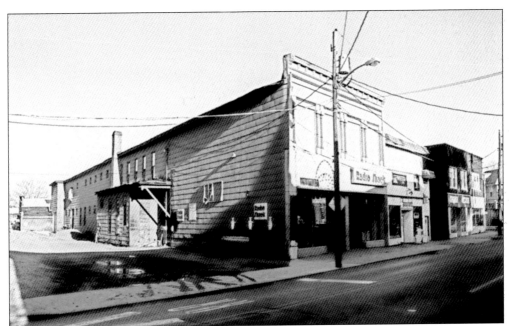

The Jacob and Keller Building is shown here on South Michael Street. For many years, the building was occupied by Widmann and Teah Pharmacy. Goetz's Hardware and Feed Store was once located in the rear. Recently the front was occupied by Radio Shack and the rear by Russ Hanes Tires. This building is scheduled for demolition in 2006. (Courtesy Dennis McGeehan.)

The Flatiron Building probably got its name from the triangular building in New York City. This block has been remodeled since this 1960s image was taken. There have been many businesses located in this building, probably none more memorable than the Times Square Restaurant, better known as Nips, operated by Eugene "Nip" Lawrence and open 24 hours a day. (Courtesy Christopher Dill.)

The Temple Theater on Brussells Street, which was built in 1905 and burned in 1922, was Elk County's largest and most glamorous showplace. Touring companies from New York City as well as local talent performed here. The foundation was later built on and used as a Pennzoil Service Station, Chrysler Showroom, A&P Foodstore, C. P. Harvey ESSO offices, and currently Hunt Oil.

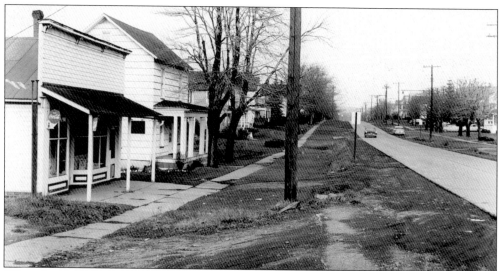

When South St. Marys Road was paved in the 1930s, it received the now quaint designation, Million Dollar Highway. When the Boulevard was constructed in the 1950s, this section of South St. Marys Street was widened. The building on the left is Meisel's Bakery, famous for its homemade rye bread. The roadway was further developed in the 1970s.

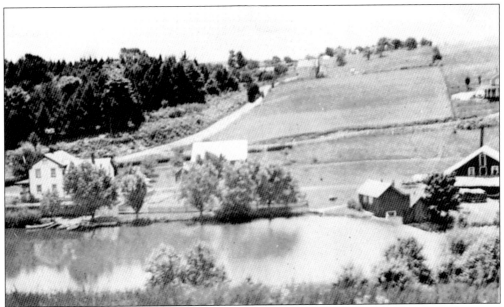

Zwack's Pond later became Zwack's Grove, a popular picnicking and boating park on the site of the old Niemiller's Sawmill, which had dammed up Iron Run. South St. Marys Road, running through the photograph, has been developed into the Million Dollar Highway, which is currently the main thoroughfare into St. Marys. The St. Marys Plaza is today located at the top of the field in this photograph.

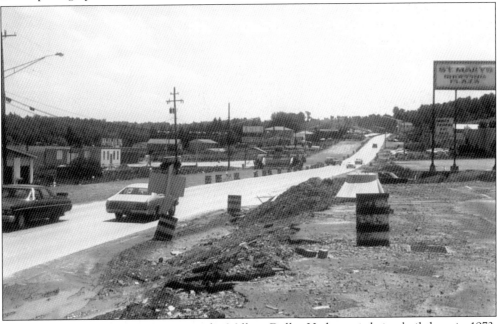

The four-lane highway, now known as the Million Dollar Highway, is being built here in 1973. St. Marys commercial growth expanded south of the downtown area. St. Marys Plaza is on the right and Ames Plaza (currently a Chevrolet dealership) is on the left. Other businesses located here were the Pepsi Bottling Plant, Sears, a Ford dealership, and many fast-food restaurants. The strip became St. Marys prime commercial district. (Courtesy Christopher Dill.)

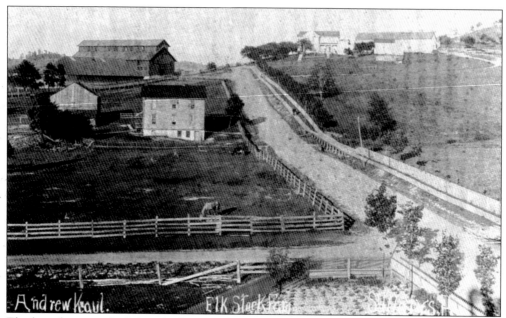

The large barn on the left is Andrew Kaul's Elk Stock Farm, where racing horses were stabled and trained. The barn was located on Theresia Street. Across Brussells Street from the stock barn was the residence of Andrew Kaul, later the St. Walburga Home. Andrew Kaul's son, William Kaul, was the veterinarian for the farm and helped raise the horses.

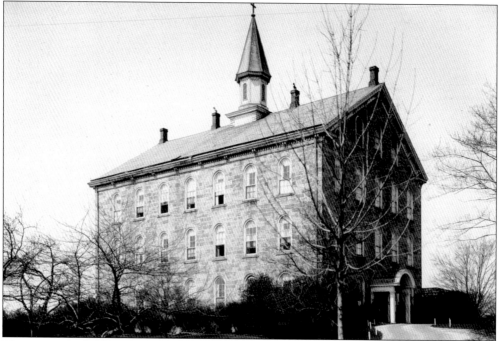

The monastery building was intended to be St. Gregory College, but was never used for that purpose. It served as the local Benedictine priest's residence. The Benedictine owners leased the area as a farm to the Pilz family. In 1920, the building was purchased by the daughters of Andrew Kaul and became the Andrew Kaul Memorial Hospital, operated by the Benedictine nuns.

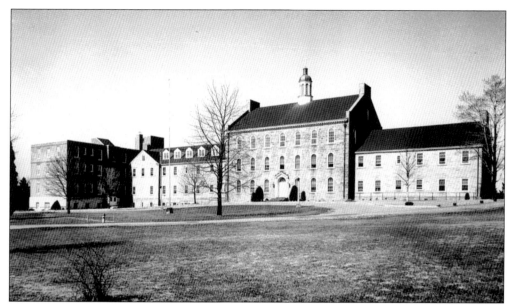

In this photograph, the Andrew Kaul Memorial Hospital has had additions built on each side of the original monastery building. This is a view of the hospital after the first modern wing was added in 1957. Today the complex includes numerous medical related buildings and is known as the Elk Regional Health Center, St. Marys Campus.

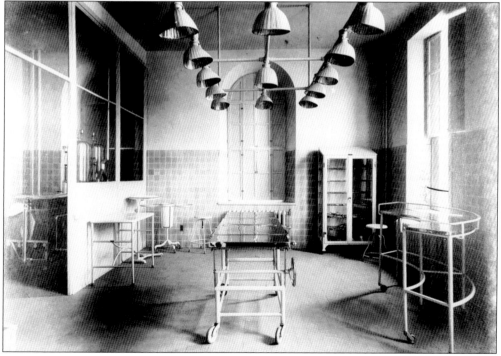

Here is the Andrew Kaul Memorial Hospital Operating Room, as seen in 1922. The facility looks primitive by today's standards. The St. Marys medical facility has kept up with the times and today uses state-of-the-art technology and is the largest employer in the county. It serves the needs of the entire region.

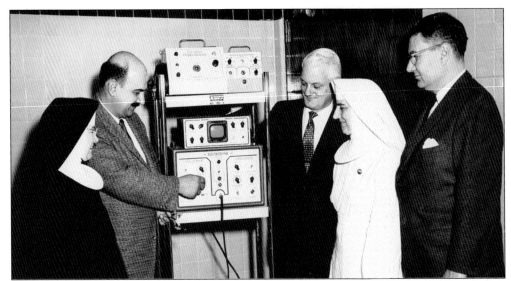

St. Marys medical services have kept pace with the emerging technologies of the modern world since its founding as the Andrew Kaul Memorial Hospital (now the Elk Regional Health Center, St. Marys Campus). In this photograph from left to right are Sr. Cornelia, OSB (hospital administrator); Dr. Stephen Chilian (anesthesiologist); Dr. John. T. McGeehan (surgeon/radiologist); Sr. Paula, OSB (nurse); and Harrison Stackpole (hospital board member) examining a new cardiac monitoring machine.

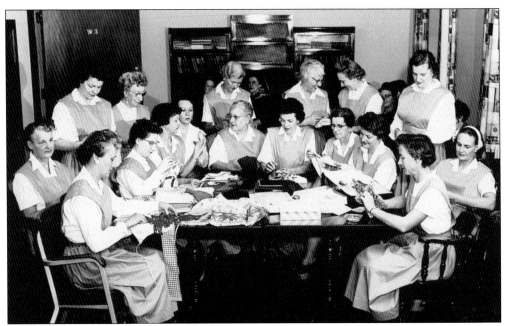

Ladies of the Andrew Kaul Memorial Hospital Women's Auxiliary in the late 1950s are busy making Christmas decorations. This organization started many programs to support the hospital, including the hospital snack bar and gift shop, candy stripers program, and the Resale Shop. They also organized an annual charity ball. The hospital has experienced much growth since this photograph, but the women's auxiliary is still an important part of this vital community service.

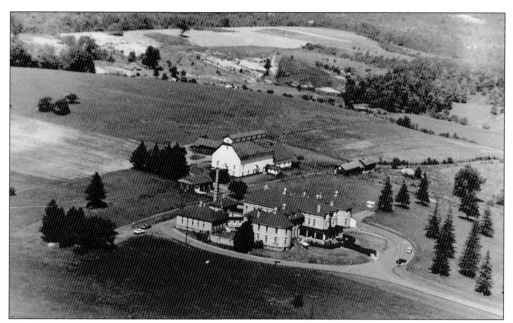

The Elk County Home complex on West Creek Road was built in 1899 and destroyed by fire in 1997. The structure had one wing for males and one for females. It was a working farm and included a chapel, hospital, dispensary, laundry, bakery, and storeroom. There were four cells in the basement if the need arose. It was replaced by a more modern facility on the hospital grounds.

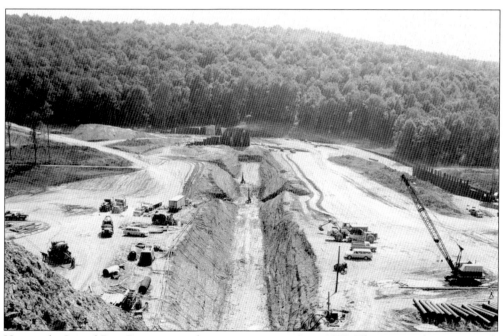

Here is the Laurel Run Reservoir under construction in June 1970. The view is the core trench for the breast of the dam. The spillway is on the far side in this photograph. The dam created a lake one and a half miles long, covering 100 acres and impounding 875 million gallons of water. The reservoir was filled in March 1971 and became operational in October 1971.

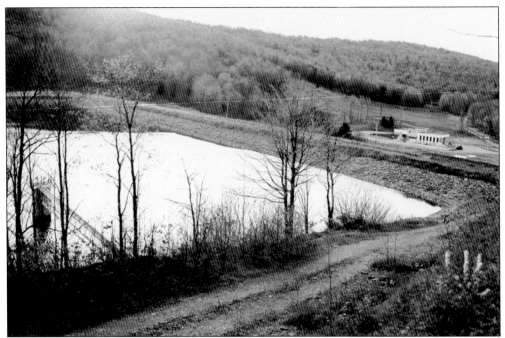

St. Marys experienced severe water shortages in 1951 and 1966. Water quality and quantity were hampering the growth of the community. To resolve this situation, the Laurel Run Reservoir was built in 1970–1971. On the left is the intake tower in the lake. Below the breast of the dam is the control house and filtration plant. The facility is capable of pumping 5 million gallons of water per day.

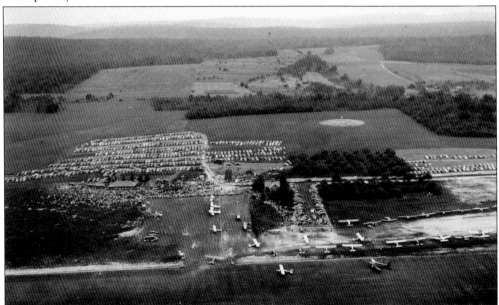

Here is an aerial view of the St. Marys Airport at the end of South Michael Road. The large crowd is gathered for the dedication of the facility in July 1950. The airport opened with a sod runway that was later paved. A rotating beacon was added in 1958, and runway landing lights were added in 1963. This view is looking south into the Wolflick Run area.

Five

COMMERCE

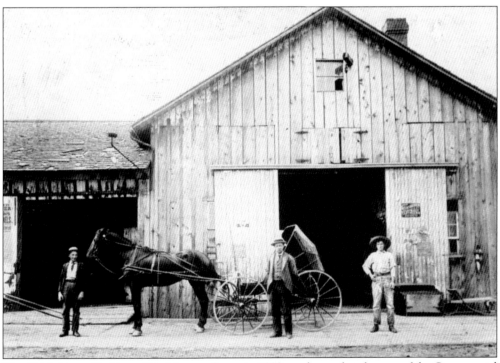

The Shirk Livery Stable on Washington Street in 1892 was located at the rear of the Commercial Hotel on Erie Avenue. This business was operated by Weis and Walker. The gentleman in the center is Henry Walker. Before the age of automobiles, a place to stable your horse, or rent a horse, near your lodging was essential.

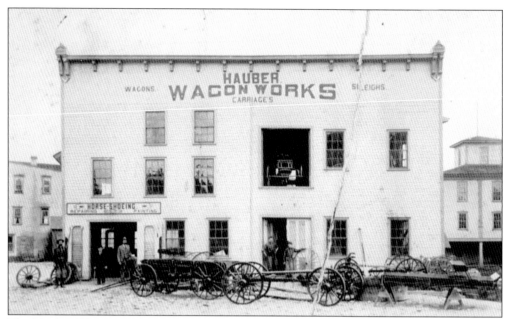

The Hauber Wagon Works was on the east side of South St. Marys Street, on the site that is now occupied by the St. Marys Pharmacy Home Health Care Center. This is an important photograph in St. Marys history because it includes a rare view of St. Marys Town Hall. The wooden town hall (right rear) burned and was never replaced. It was located where the municipal parking lot is today.

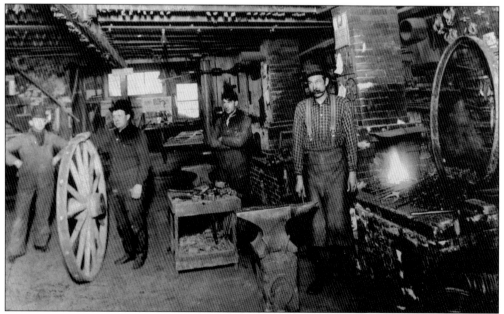

The Hauber Wagon Works, located on the east side of South St. Marys Street, shows the blacksmith with the tools of his trade: forge, anvil, hammer, tongs, and horseshoes. This business shoed horses and manufactured and repaired carriages, wagons, and sleighs. The iron ring hanging on the wall to the right would be fitted onto the outside of a wooden spoked wheel (left) to make the wheel last longer.

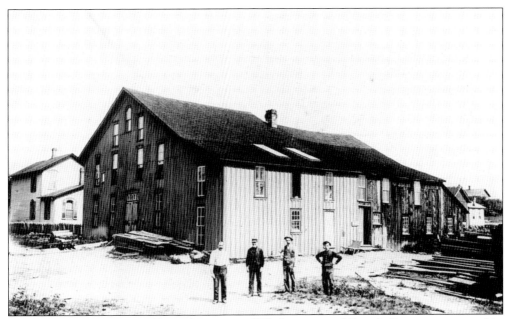

Schaut Brothers Planing Mill, on the corner of Washington and Fourth Streets, was started in 1869 by George Schmidt and purchased in 1871 by George Schaut and Joseph Forster. In 1883, Ignatius, Joseph, and Edward Schaut formed the Schaut Brothers Manufacturing Company. The structure burned in 1926. This planing mill manufactured the lumber for many of St. Marys businesses and homes.

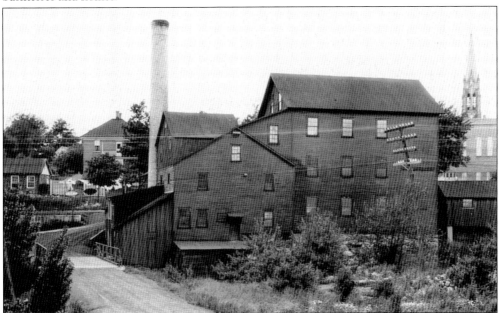

Leonhard Ritter's Mill, on Elk Creek, was formerly operated by R. C. McGill. The mill ground local farmer's grain and eventually included a foundry, broom factory, and machine shop. During Prohibition, it was raided for making illegal moonshine whiskey. This photograph is from the 1960s, just before it was torn down. Note that in the right rear is the Sacred Heart School and Church steeple.

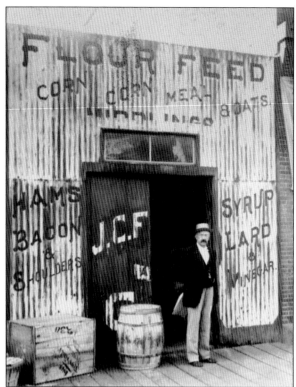

Charles Luhr is standing in front of the J. C. Frank and Company Grocery Store on Railroad Street, of which he was co-owner. Luhr was a community leader and served in many borough, county, and state political offices, including mayor and judge. He delivered the main address when the Elk County Courthouse cornerstone was laid in Ridgway. Luhr's home on Center Street is now the Sacred Heart Rectory.

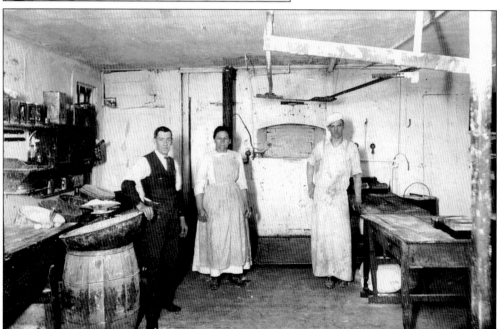

This is a view inside the Joseph Imhoff Bakery. Bread and baked goods were baked in many shops around St. Marys before commercially baked bread was shipped into St. Marys from outside. The Imhoffs later operated a grocery store at the corner of Washington and Lafayette Streets. Shown from left to right are baker Joseph Imhoff, his wife, Anna, and their son Andrew.

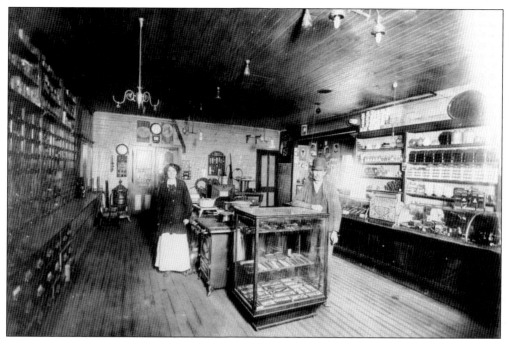

Burden Hardware and Tin Shop, on South Michael Street, was a hardware store in front and a tin shop in back. Pictured are Harry S. Burden and his niece Dolly Bauer Schatz. Businesses later located at this site were Hays Drug Store, Kronenwetter's Dress Shop, The "Hippie" Store, Pinball Arcade, Lynd Tires, Town Crafts, and Dough Boys Pizza.

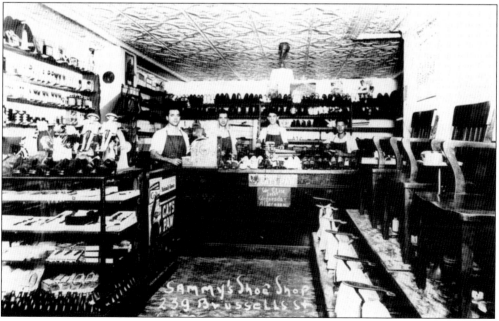

Sammy's Shoe Shop was on Brussells Street in 1939, where Dostal's Curiosity Shop is today. Employees shown from left to right are Tom Posteraro, Sammy Posteraro (proprietor), Frank Carino, and Dom Piccolo. Note the shoeshine chairs on the right. Back then, worn shoes used to be repaired, and there were many shoe repair shops in St. Marys. Note the pressed tin ceiling.

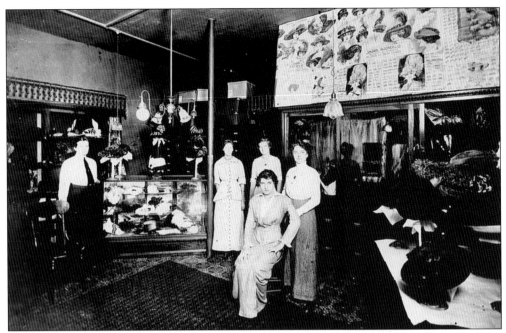

Josephine Klausman's Millinery Shop was located in the Lesser Block on Brussells Street. This shop was a style setter in St. Marys for many years. At one time, an elegant lady's attire was not complete unless it was topped off with the latest fashion in headgear. The time when a ladies hat was a fashion statement has gone like many other customs.

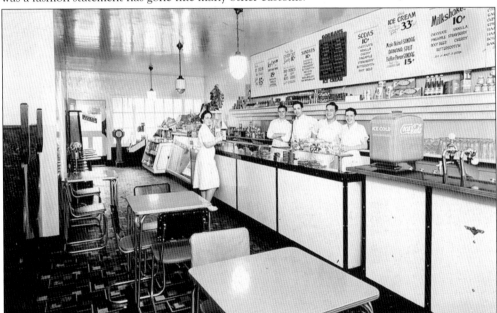

Gormans Soda Fountain on Railroad Street is seen in this photograph around 1940. Sit-down soda fountains were very popular before the drive-through service of the modern era made them obsolete. Gormans served ice-cream sodas for many years on the south side of the Diamond. The employees in the photograph from left to right are unknown, Robert "Knobby" Kronenwetter, Pat Gorman, unknown, and Wally Bickmire.

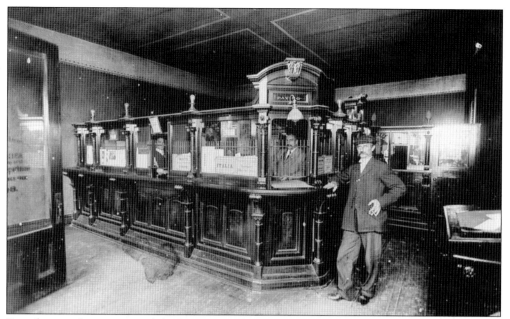

Seen here is the opening of the Farmers and Merchants Bank in 1902. Shown are M. Bauer, J. Finfinger, and an unidentified customer. This building is located on the corner of North Michael and North St. Marys Streets. It was built by John Weidenboerner shortly after the great fire of 1880 burned much of the downtown. It was the first commercial brick building in town.

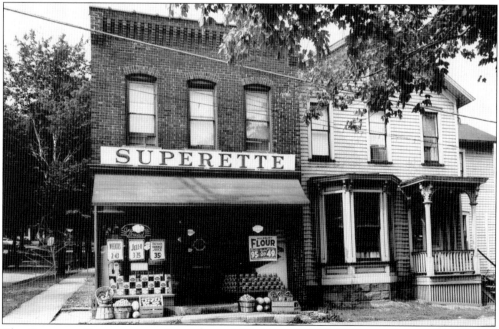

The Superette Store was on the corner of Washington and Lafayette Streets. There once was a time when grocers displayed their produce outside the store to entice customers. Other businesses located here were Imhoff's Ice Cream Parlor, A&P Foodstore, the St. Marys Water Company office, and various insurance, accounting, beauty shop, barber shop, and travel agency businesses. The building on the right was formerly the Odd Fellows Hall.

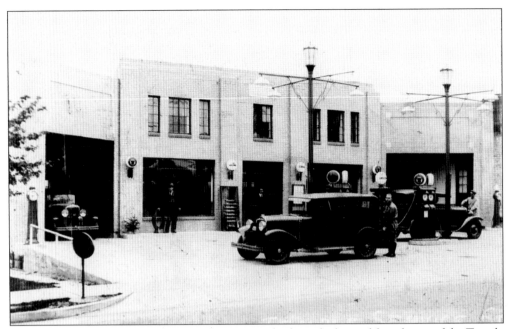

The Temple Service Station on Brussells Street was built on the burned foundation of the Temple Theater. Other businesses that were located here were the Chrysler Auto Showroom, the A&P Foodstore, Charles P. Harvey Distributors, and Hunt Oil. This was a time when attendants not only pumped gas but also wore uniforms to do so. Note the fancy light standards.

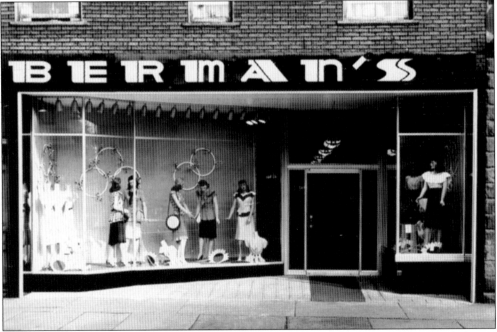

Berman's Dress Shop was the center of style during much of its operation for the ladies of the St. Marys region. Joe Berman sold ladies fashions on the south side of Erie Avenue for 43 years, originally opening in 1937. Berman was a colorful character and well known for his radio commercials, which starred Berman himself.

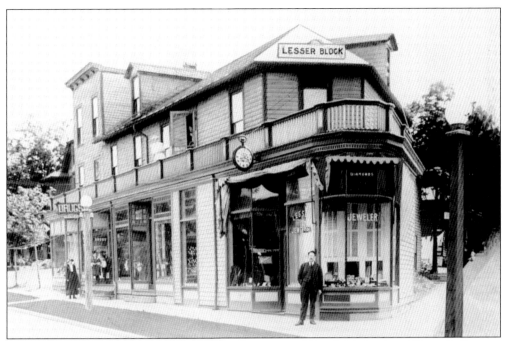

Here is a photograph of the Lesser Block at the corner of South Michael and Brussells Streets. In 1910, Leonard Lesser bought the entire block that included his jewelry store, and the business has been in the Lesser family ever since. The clock mounted over the store entrance is a St. Marys landmark that St. Marys residents often consult.

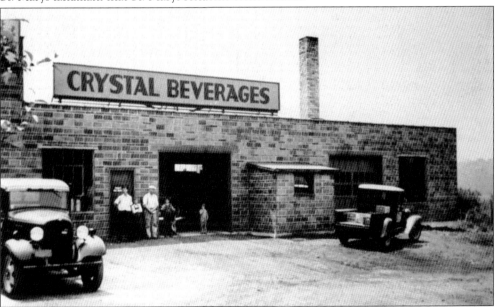

This 1937 photograph shows the Crystal Beverage Company, which was located on Maurus Street behind the West End Service Station. It was owned and operated by the John Kuntz family. In 1929, the company bottled the popular beverage Moxie. In 1938, the firm secured a Pepsi Cola franchise. In 1964, the company moved its operation to its new Pepsi bottling plant on the Million Dollar Highway.

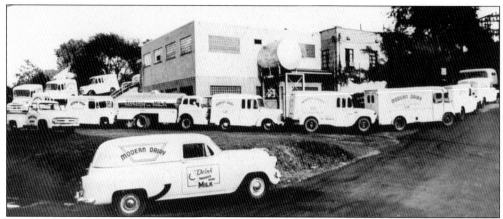

The Modern Dairy plant was on the corner of State and McGill Streets. Modern Dairy employed a fleet of trucks to deliver to a wide area. The Gregory farm on Sugar Hill was one of the area farms supplying milk to the plant. The front of the plant had a small retail store that was a popular stop for ice cream for many years.

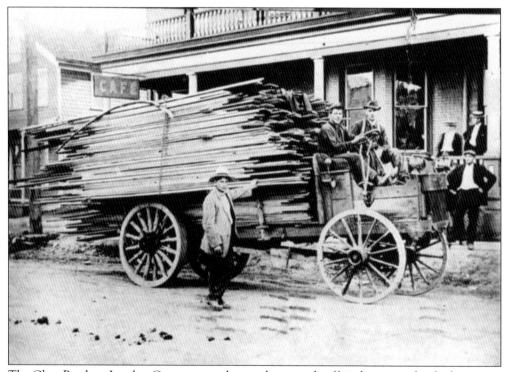

The Glass Brothers Lumber Company truck was a homemade affair that excited onlookers every time it came down the street. It could be loaded with 7,000 feet of lumber weighing 13 tons. It later was used as a portable sawmill with its own edger and 5-foot circular saw. Built by the Glass brothers of Ford Road, it was first used in the Fourth of July parade of 1909.

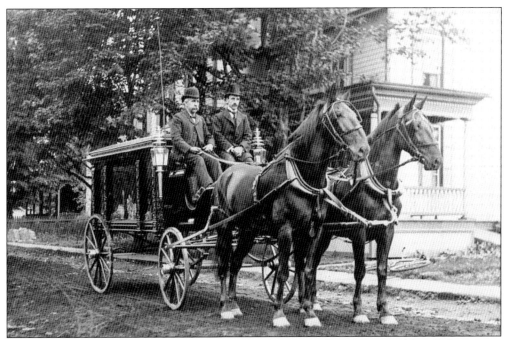

Shown is the Weis Funeral Home hearse. The driver is Albert Weis, and beside him is an undertaker identified as Smith, with appropriate somber dress and expressions for their profession. Note the fancy lanterns mounted beside the driver and the glass siding, allowing mourners to see the casket. The Weis Funeral Home was located on South St. Marys Street.

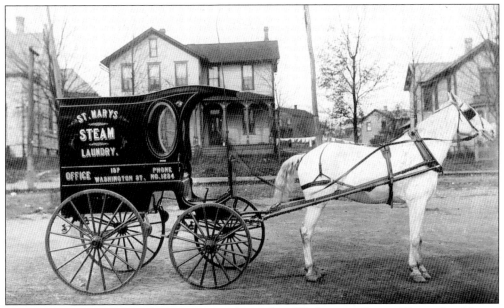

The St. Marys Steam Laundry business was located on Washington Street. This is the delivery carriage of that firm. Before the automobile age, St. Marys had many different businesses, which have passed from the scene, that serviced the carriage trade. Livery stables quartered horses, blacksmiths shoed horses, feed stores fed horses, carriage shops repaired the carriages, and wheelwrights kept them rolling.

This Farmers Hotel photograph dates from around 1910. The hotel was built on the site of an earlier business, the Zelt Hotel, at the intersection of South Michael and Chestnut Streets. The occasion is a gathering of the International Order of Odd Fellows. In the left background the Sacred Heart steeple is visible. The Benzinger House Hotel, on South Michael Street, can be seen in the right background.

The Mullendean Hotel, on the north side of Erie Avenue, was built in 1906 on the foundation of an earlier hotel. It was called the Commercial Hotel before changing its name to the Mullendean. It was torn down in 1967. The band in the photograph was the award-winning State College Band that was passing through St. Marys on its way to a performance.

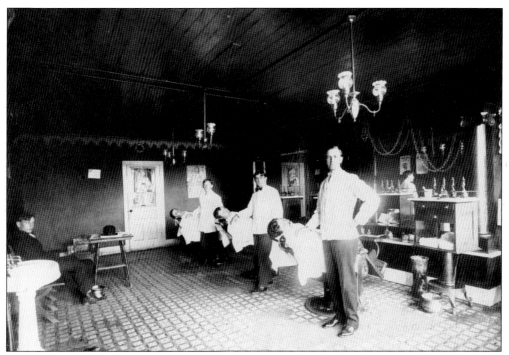

Pictured is the Leibel Barber Shop located on Erie Avenue. There was a time when St. Marys boasted of a three-chair barber shop and filled all three chairs, with customers waiting. The barbers are, from left to right, Andrew Schauer, John McMackin, and William Leibel. There were many barber shops in St. Marys throughout the years. Many hotels had barber shops in their lobbies.

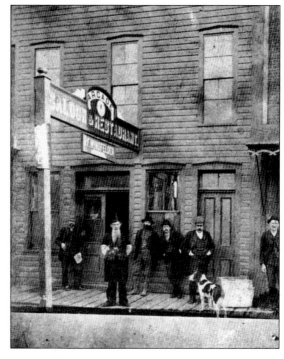

The Arcade Saloon and Restaurant was on South Erie Avenue. The proprietor, Joseph Windfelder, is in front in top hat and bartending sleeves. Windfelder served as mayor of St. Marys. He built a brewery on Center Street along Brewery Run, which was later operated by the Luhr brothers. The white object on the wooden sidewalk (right) is a block of ice. Today Smith's Sport Store occupies the site.

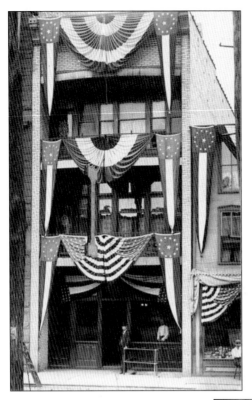

The second Arcade Hotel on the south side of Erie Avenue is decorated for Old Home Week in 1906. In 1923, Ray Smith opened an Army/Navy store in the building, which later became Smith's Sport Store. On the right was a general store and bowling alley and on the left the H. M. Silman Department Store.

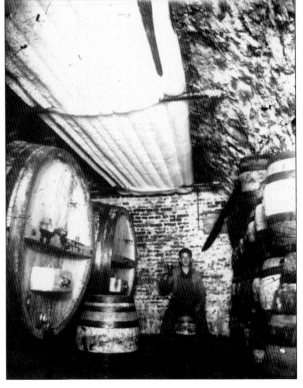

An interior view of the Luhr Brewery on Center Street, which operated between 1851 and 1900, is shown in this photograph. Henry Luhr purchased the brewery from Joseph Windfelder. The original brewery was built in 1865. This view is of the cellar where the beer casks were stored. The brewery was located just west of the present American Legion on Center Street and Brewery Run, which has since been covered.

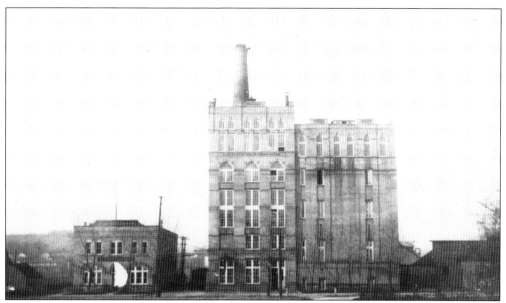

St. Marys Brewing Company on Hall Avenue was the largest brewery in St. Marys. It produced several different brands, including Ault Deutscher beer. The brewery made near beer during Prohibition and was cited several times for having too much alcohol in the product. The building was turned into a carbon plant by Pure Carbon Company, which removed the chimney and the top floor.

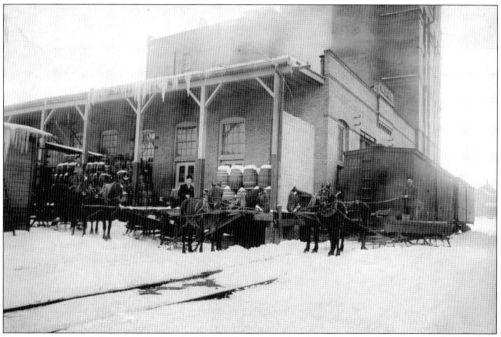

This is a view of the rear of the St. Marys Brewery, which had railroad sidings on both sides. Boxcars brought in hops and grain. Horse-drawn sleighs delivered ice from local ponds in winter. Shawmut Railroad refrigerated cars delivered St. Marys beer throughout a wide area of western Pennsylvania and New York.

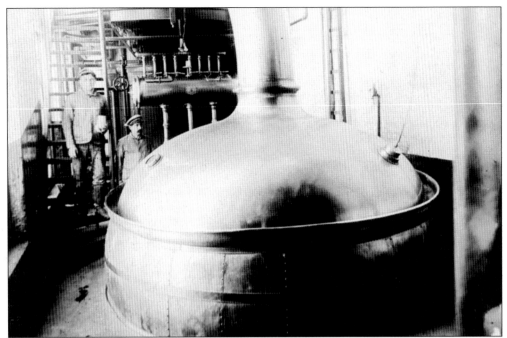

The St. Marys Brewery Brew Room contained a kettle that was two floors high. This copper kettle was purchased by the Straub Brewery when St. Marys Brewing Company closed. The kettle was moved up the hill and used there for many years. The brewers in the photograph are Pete Straub and Jake Sorg.

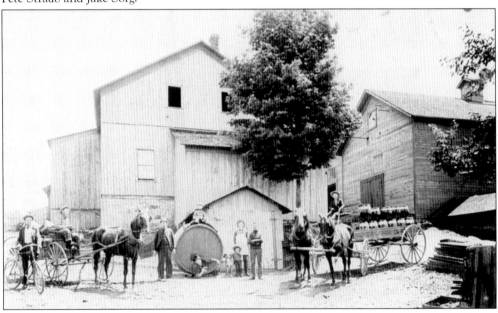

Here is an early view of Straub Brewery in 1895. Originally known as the Benzinger Spring Brewery, it produced pilsners, lagers, seasonal bocks, and an extra-strong brew called Ulmar Salvator. Figures in the photograph are, from left to right, Peter P. Straub (with bicycle), Frank Straub (on wagon), brewer Peter Straub, child (on barrel), John Kraus Sr. (cooper), child, Joe Straub, Jake Sorg, and Tony Straub (on wagon).

Straub Brewery workers take a break. Straub brewery founder and brewmaster Peter Straub is flanked by his sons Frank (left) and Joseph (right), who is holding a bung mallet to pound the large corks into the side of the wooden kegs. Straub Brewery is known today for its Eternal Tap where tourists can sample the product as long as they wash their own glass.

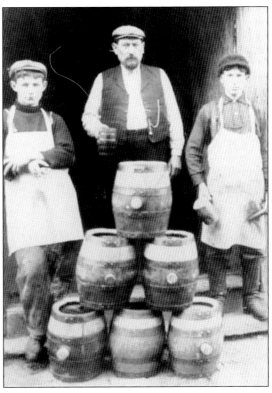

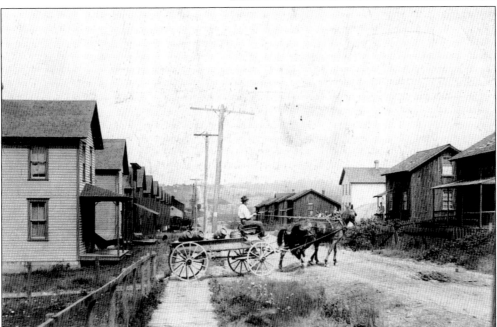

The Straub Brewery delivery wagon is shown delivering beer kegs on Brussells Street in 1906. The driver is identified as Charles Dippold. Used refrigerators were always scarce in St. Marys, as many residents had keg refrigerators in the basement or down at camp. The beer delivery wagon was a familiar sight. St. Marys residents are fiercely loyal to the local brew.

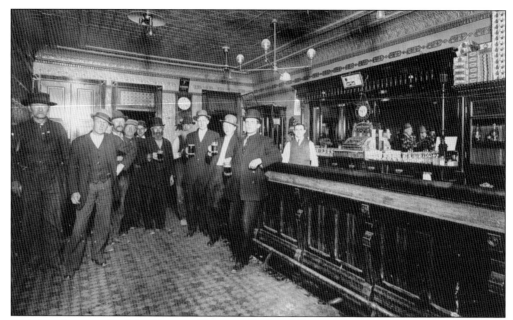

This is a photograph of the German House on Railroad Street. The patrons from left to right are Matt Hirsel, woodsman; George Hoehn Jr., painter; Randy Herzing; Henry Beecher, stonemason; Ben Frank; George Beimel; ? Emmert; ? Daniels; Henry Smith; Henry Hacherl; and Henry Groll, bartender. Note the large stack of cigar boxes in the upper right. Over the years, St. Marys had seven different breweries supplying beer to local taverns.

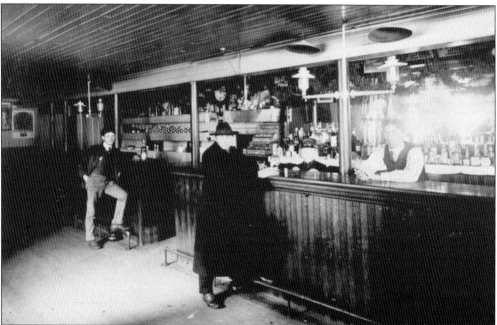

The Commercial Hotel bar is shown in this photograph. The barroom in the basement was known as the Bull Pen. It appears that regulations concerning the minimum drinking age were more lax back then on both sides of the bar. Many bartenders wore a tie and vest to lend an air of class to their establishments.

Six

FROM TRAGEDY TO TRIUMPH

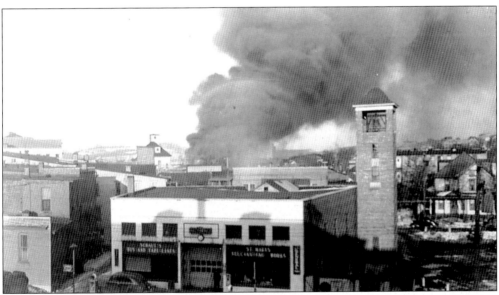

A fire rages in downtown St. Marys. The Shawmut Railroad shops on Depot Street are burning on March 19, 1941. This view was taken from the roof of the Franklin Hotel. The building in the foreground is the Schaut Bus and Taxi Company. Beside it is the St. Marys Memorial Bell Tower. The tall structure in the background, left of the smoke column, is the Lewis and Bauer grain silo.

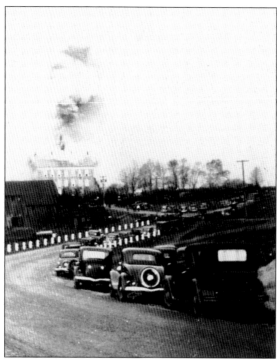

The Andrew Kaul Memorial Hospital is shown here on fire on the day after Thanksgiving, November 27, 1934. The building was originally the old monastery and is currently part of the Elk Regional Health Center, St. Marys Campus. Cars are lined up on the hospital curve to view the spectacular fire. Note the Pilz farm barn on the left.

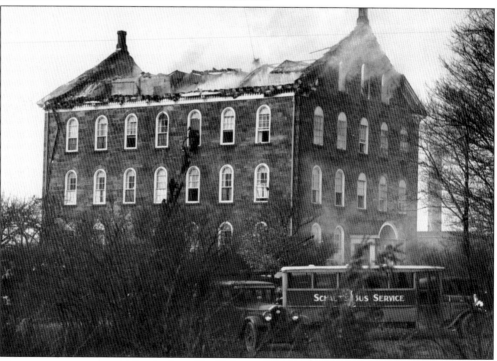

Firemen attempt to enter the Andrew Kaul Memorial Hospital's third floor by ladder to fight the fire in November 1934. After the fire, the hospital moved into the St. Benedict's Academy on the convent grounds temporarily. The hospital expanded by erecting additions on both sides and reopened in 1941. Note the Schaut Bus Company vehicle in the foreground.

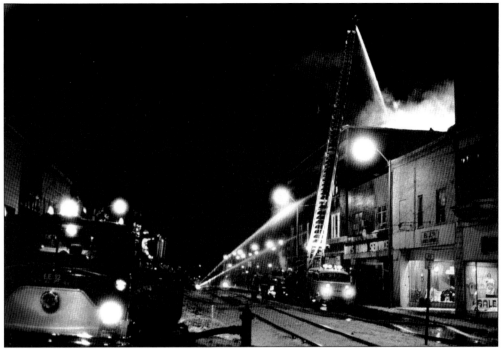

The St. Marys Crystal Fire Department battles the Moose Lodge fire on Erie Avenue. It was a very cold night, and eventually the entire block became coated with ice. The Moose building had to be torn down, but a new Moose building arose on the same site. The Moose Lodge started in the City Hotel on the same site, and that building also burned. (Courtesy Ray Beimel.)

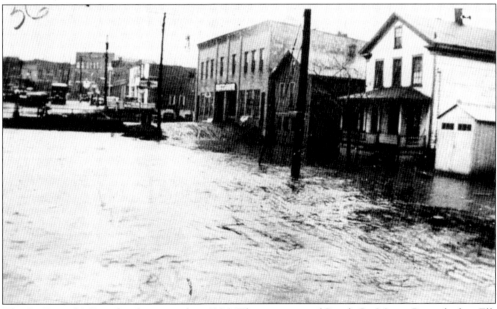

The St. Patrick's Day flood occurred in 1936. This is a view of South St. Marys Street before Elk Creek was covered. The creek bed is directly under this mass of flowing water. Note the bridge across the creek in the right rear. Beyond the bridge is the Diamond. The large, square building on the right is the Wittman Building, which contained a Ford dealership.

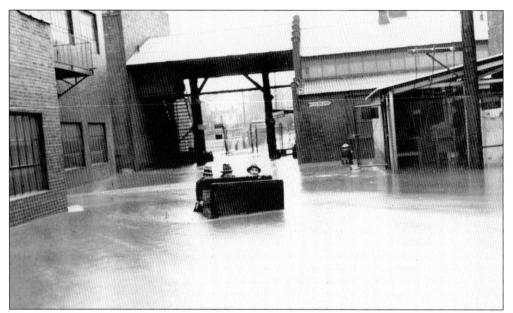

Here is another view of the St. Patrick's Day flood of 1936. This is a scene inside Stackpole Carbon Company. Elk Creek has overflowed its banks and flooded the factory. The workers are shown trying to salvage material. This area is prone to flooding, and the river has been over its banks many times through the years.

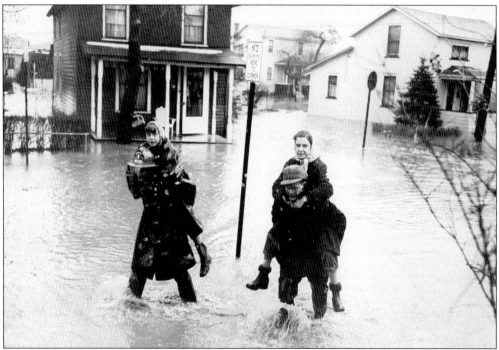

Floods also affected residential areas. This scene is at the intersection of Fourth and Depot Streets. In the photograph, St. Marys fireman Leander Rupprecht is shown rescuing Susan Byrd (left) while Jim McQuone is rescuing Janice Byrd from Elk Creek, which has taken over these borough streets. This intersection has flooded often.

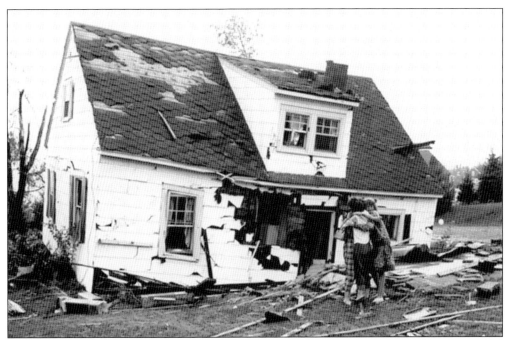

Devastation caused by the tornado of September 3, 1963, is depicted here. Twin funnels touched down near the Johnsonburg Road, damaging the Lynchville section and the Bucktail Trail trailer park. The storm caused $1 million in damages, including many downed electric lines, 200 broken telephone poles, and impassable streets. The only serious injury was a broken leg. This photograph shows damage in the Lynchville section of St. Marys.

During the tornado of September 3, 1963, this doghouse on Washington Street, with dog attached, was carried away by the high winds. The dog landed unharmed and became quite a canine celebrity after its unwilling flight. Note the large, uprooted tree next to the dog's final destination.

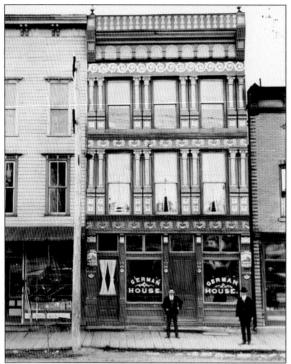

The German House hotel and barroom is pictured on Railroad Street in 1906. Shown here is Charlie Groll (bartender) and William Klausman, standing in front. Note the wooden sidewalks and St. Marys beer signs by the entrance. The door on the left with the white curtains was the ladies entrance. This is one of the more ornate buildings in town and has beautiful decorative woodwork on its facade.

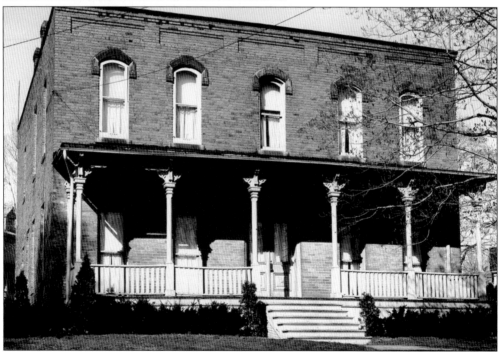

The Proctor House on North Michael Street was originally the home of John E. Weidenboerner. In 1953, it was purchased by the St. Marys Youth Council and became the home of the St. Marys Girl Scouts. The bricks for the building were baked from clay taken from the banks of Elk Creek in the tannery area. This building is on the National Register of Historic Buildings.

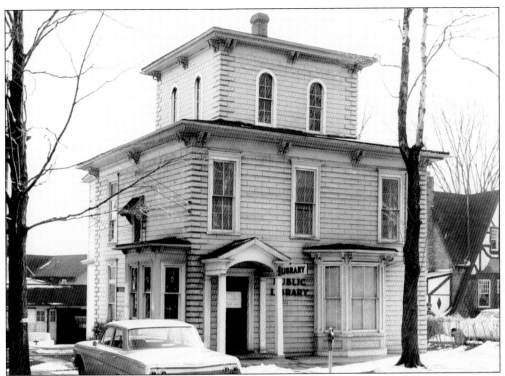

The old St. Marys Public Library building on Center Street was originally the home of St. Marys Coal Company's Dr. Eben J. Russ. Russ donated this building in 1921 for a library after he built a new home across the street. Russ also had business, mining, and lumbering interests. The building was built in 1879 and razed in 1966 to make way for the new library building.

The second home of Dr. Eben J. Russ on Center Street was built in 1913. During the influenza epidemic of 1918, Russ worked tirelessly to treat the sick. He was instrumental in turning the newly opened Elks Building into a temporary hospital. His wife, Clare, was an accomplished singer and musician. This mansion is currently used as part of the Towne House Motel complex.

This is the C. A. Lion house on Center Street in 1912. It was later owned by William Kaul and still later housed the Battery B Headquarters of the U.S. Army Reserve. In 1992, the Elizabethan, half-timbered Tudor-style house and adjoining carriage house were purchased by the Towne House Motel complex and renamed the Willows.

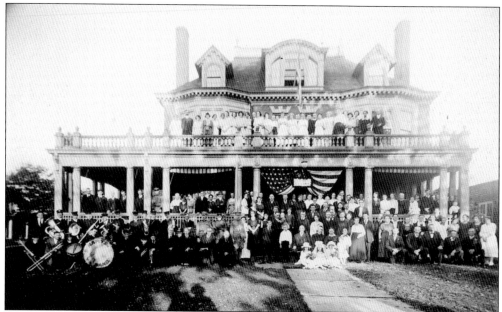

The J. K. P. Hall mansion was located on the corner of East Mill Street and South St. Marys Street. Hall was a lawyer, entrepreneur, and state senator. The building was later used by the Catholic Men's Fraternal (CMF) Club before it burned in April 1964. This photograph shows a celebration of the first mass of local resident Fr. Jerome Rupprecht, who can be seen on the front steps flanked by his parents.

The residence of Andrew Kaul was at Brussells and Theresia Streets. Andrew Kaul was a prominent entrepreneur in early St. Marys history. He was involved in timbering and later the carbon industry. His important business ventures were the Hall and Kaul Sawmill and Speer Carbon Company. This Victorian structure was built around 1880. In 1927, the home became the St. Walburga Home for retired women. It was demolished in 1977.

Shown here is the Harry C. Stackpole mansion on Maurus Street in 1948. Stackpole was the founder of the Stackpole Battery Company, later Stackpole Carbon, which became the largest employer in Elk County. In 1948, the house was willed to the Benedictine nuns and used as a nurse's home. The roof of the handsome structure was tiled with red and gray slates.

Built in 1916, this is the first residence of H. C. Stackpole on the corner of North Michael and Maurus Streets. In the late 1930s, it became the John J. Lynch Funeral Home and today is the Lynch-Green Funeral Home. On the left is the D. J. Driscoll house, and on the right can be seen the building that once housed the St. Marys Police Department. (Courtesy Dennis McGeehan.)

This beautiful home on North Michael Street was the home of prominent St. Marys resident Congressman Dennis J. Driscoll. Driscoll arrived in St. Marys in 1890 as a teacher. He later became a lawyer and was elected to Congress. The stately Corinthian columns, roof deck, and second-story verandahs have since been removed.

Seen in this photograph is the home of industrialist George Simons on Center Street. Just to the left of this building is where Brewery Run (since covered) crossed Center Street and was the location of the Windfelder-Luhr Brewery. The building is currently the home of the St. Marys American Legion. It is one of the more stately mansions in St. Marys. (Courtesy Dennis McGeehan.)

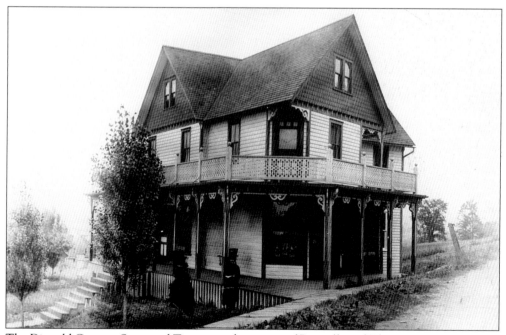

The Dippold Grocery Store and Tavern on the corner of Brussells and Theresia Streets is shown here. It was later known as Tailspin Dips, as longtime proprietor Earl Dippold was an early pilot. Today it is known as the East End Tavern. The storefront has been closed in and the upstairs balcony removed.

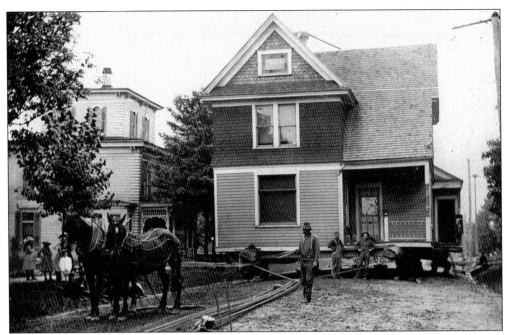

This is a view of an entire house being moved down Center Street with a team of horses, rollers, and block and tackle. Houses were sometimes moved short distances rather than being dismantled. The Eben J. Russ home can be seen on the left. The horse team is being managed by one-armed Mr. Flickenger and assisted by Joseph Erich and his son Joseph. The horses were Sal and Doll.

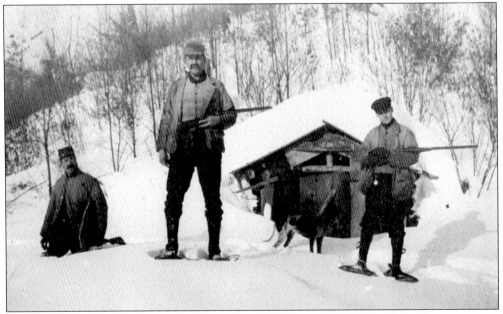

Camps and hunting have always been an important part of St. Marys life. Hunting camps abound, both simple and elaborate. In the early days of the colony, hunting put food on the table. In this photograph, the hunters are using snowshoes as they head out with their hound. Note that the hunter on the left, without snowshoes, has sunk up to his hips in the deep snow.

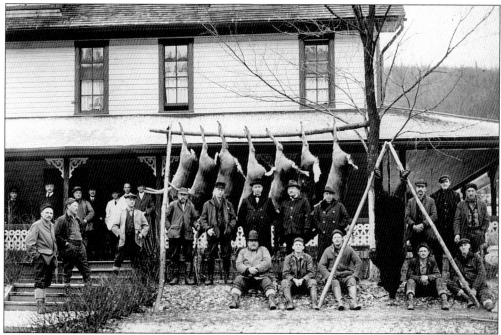

The Trout Run Hunting Lodge has been organizing a hunt for over 100 years. The camp was built on land owned by the lumber baron Andrew Kaul and is still owned by his descendants. Deer hunting and its cuisine are an important part of St. Marys culture. Note that in the photograph the hunters have also harvested a bear during the hunt.

Successful hunters follow a tradition in St. Marys to have a photograph of their trophies taken for the local newspaper. Through the years a variety of interesting shots have appeared in its pages including rare animals, big fish, rattlesnakes, and albino animals. This man, wearing a suit and bowler hat, which were probably not his hunting clothes, is holding up a bear.

Paul Simbeck poses for a studio portrait with a brace of snowshoe hares that he and his trusty beagle have run down. St. Marys lies in a northerly clime, and these northern mammals are common, if not plentiful, in the area. The snowshoe hare has a brown fur coat in the summer, turning white in the winter. Note the hunters camouflage togs, which work well in winter.

This photograph shows kiddies fishing day at the St. Marys Sportsmen's Club. The Sportsmen's Club has a long and active tradition in the social life of St. Marys. Behind the Kiddies Fishing Pond is the big barn, home of many dances, picnics, weddings, parties, and numerous other events. The kiddies fishing day is an annual, well-attended event.

Handed down from father to son, St. Marys traditions endure through generations. A young boy holds on tightly to his first fish and his father's, or grandfather's, guiding hand at the St. Marys Sportsman's Club kiddies fishing day. Fishing is a popular activity in the St. Marys area, and a lifetime of recreation often starts here, with a simple willow twig pole.

It's not the size of the fish and it's not the age of the fisherman, it's the experience. St. Marys, on the headwater divide, has plenty of first-class trout streams in the area. The first week of the fishing season sees many sportsmen filling up local camps in search of angling trophies. St. Marys has many stories of legendary fishermen who knew of secret fishing holes and perfect days afield.

Shown in this photograph is Michael B. Zwack around 1908. The Zwack family ran a picnic grove just south of St. Marys. It was a popular recreation area for many years and included a small dam on Iron Run. The park had a picnic pavilion and ball field. In the pre-motorized era, hiking was a popular pastime and many area residents hiked to popular tourist destinations such as Zwack's Grove.

An unidentified man, dressed in suit and bowler, poses on Bum Rock on Iron Run just below Zwack's Grove. This was a natural curiosity that is a popular hiking destination in the St. Marys area. Bum Rock got its name for the shelter it provided itinerant folk who may have generously used the nearby railroad.

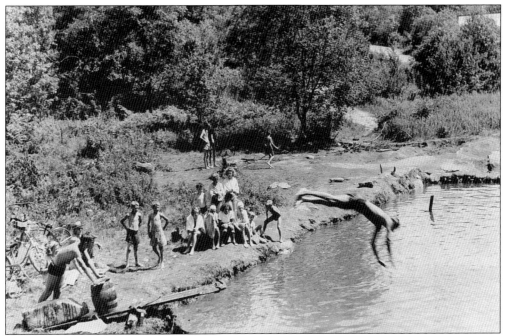

Seen here is a sandbag dam swimming hole on Silver Creek in the late 1940s. The location is just above the highway bridge where the Johnsonburg Road crosses Joseph Road. Visible at upper right is a billboard along the highway. Silver Creek was a popular swimming locale for many years before chlorinated, concrete, artificial ponds. Note the large rock and wooden beer keg used to hold down the diving board.

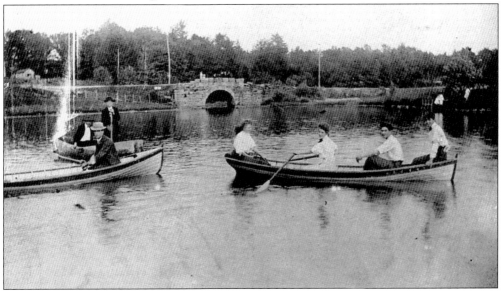

Shown here is summertime boating on Zwack's Pond. This picnic grove was a popular recreation area for many years. The pond, on Iron Run, was originally built and used for the Niemiller Sawmill. Note that in the background is the stone-arch bridge that carries South St. Marys Road over Iron Run. This road was transformed into the Million Dollar Highway by raising the roadway considerably and burying this beautiful piece of stonework.

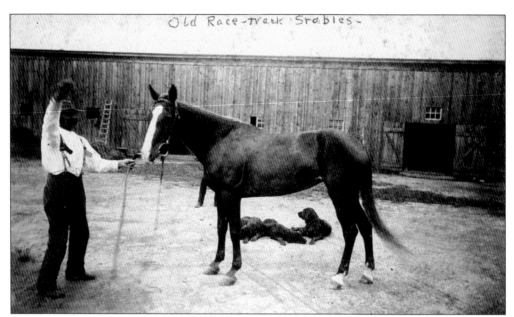

Trotting was a popular sport and attracted large crowds that offered their opinions on the ability of the horses, for financial risk. People from all over the area attended these contests. In this photograph, while the trainer is hard at work training the horses at the old racetrack stables on Theresia Street, the horse seems more interested in the photographer and the dogs seem more interested in their nap.

Henry Walker is driving a sulky on Mill Street in 1909. Horse racing was a major attraction in St. Marys. It was organized and professional. In 1883, the Elk County Agricultural and Trotting Park was founded by J. K. P. Hall and was located on Theresia Street across from Speer Carbon Company. It had an oval racetrack and grandstand with a 200-foot stock barn.

Ice-skating was always a popular winter sport, and there were several places around town where local enthusiasts could practice their skills including Memorial Park, Benzinger Park, and numerous small farm ponds. Pictured here is the Kaulmont skating pond on the east side of town between Stackpole and Speer Carbon Companies. In the background, the Shawmut Railroad coal tipple is visible, which was used to load coal into their tenders.

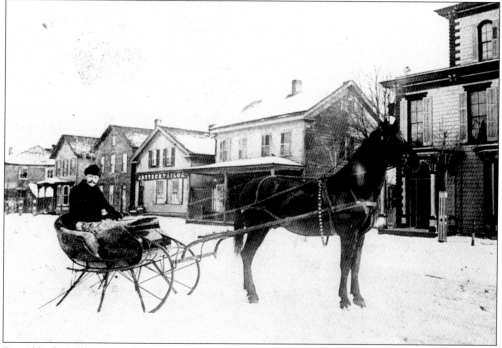

Dr. Alfred Mullhaupt is shown in his cutter on Center Street. Mullhaupt practiced medicine in St. Marys with his wife, Helena, who was also a medical doctor. He also ran a drugstore in town and later built the Medical Arts Building on the corner of Center and North Michael Streets. Mullhaupt was active in the community and served as mayor of St. Marys.

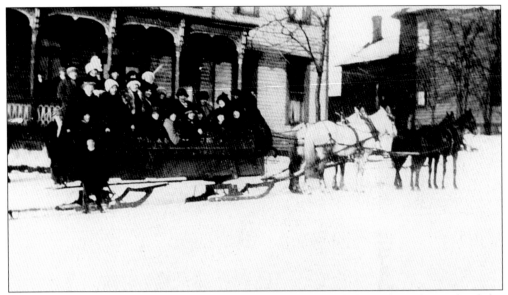

St. Marys enjoys typical northern winter weather. St. Marys people have always been a hardy lot and have chosen to enjoy winter recreation. Here a large group of residents out for a bit of the jingle bells with a team of four on a dashing sleigh is seen. Everyone seems to be bundled up in their seasonal best furs and hats.

This is Margaret Wittman aboard the Waltham Orient Buckboard, which was St. Marys first automobile. The car was tiller-steered with two forward gears and no reverse. The body, including fenders, was made of wood. It had no windshield, top, or head lamps. It had a box on the back for delivering groceries from Mr. Wittman's store. This car is still in the possession of the Wittman family in St. Marys.

There were many fans of the two-wheeled mode of transportation in the St. Marys area. The Saddlepal's Club and the Hummingbird Racetrack both offered entertainment for motorcycle enthusiasts, including organized races and touring. In this photograph, a young lady is shown with an Indian motorcycle. Note the touring clothes and cap on this motorcyclist.

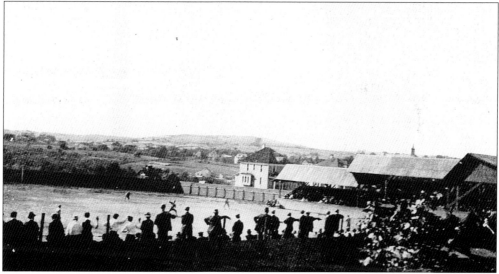

A pitcher delivers a pitch during the first game played at Berwind Park in 1914. Many community activities throughout the years have taken place here, including Halloween parades, Easter egg hunts, kite flying contests, marching band competitions, and so on. The original wooden grandstand eventually burned and was replaced by a modern steel structure. Note the St. Marys Church steeple in the background.

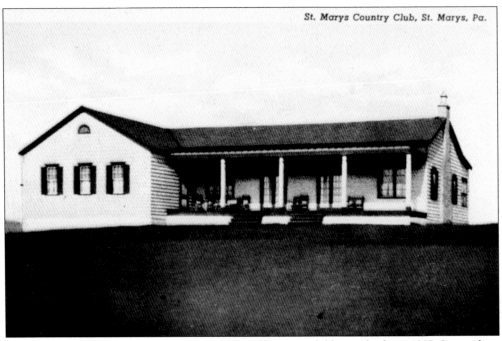

This is the original St. Marys Country Club golf course clubhouse built in 1927. It stood on blocks set in the ground and had no heating system, and the season ran from April to October. In 1966, a new clubhouse was built on the prominent knoll that is visible from all over town. Eventually, a swimming pool and tennis courts were added to the facility.

St. Marys people have inherited a love of music from their Bavarian German ancestors. St. Marys has had many organized and pickup bands. Local clubs and bars have always echoed with the notes of its music-loving residents. In this photograph, Anton Auman, local drum major, is shown in all his pomp and regalia, ready to lead the march down the local thoroughfares.

The Little Flower Music Studio was located in the St. Walburga Home on Brussells Street. Here we see the young musicians in 1935 performing in the Moose Temple for the *Sunny Jim* program on WJAS radio of Pittsburgh. It appears that some of the novice musicians may be experimenting with many different musical styles.

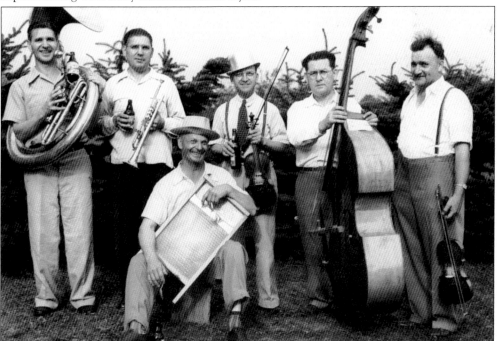

The St. Marys German Band is shown in 1947. Shown from left to right are Tony Pfeufer, John Pfeufer, John Weis, Joseph Herbst, Vinny Sherry, and Frank Weis (front, seated). Many bands in St. Marys were pickup bands without fancy uniforms or concert dates, rather, they were informal affairs in homes or fields—people making music for the sheer joy of the sounds and a cold Straub's during break.

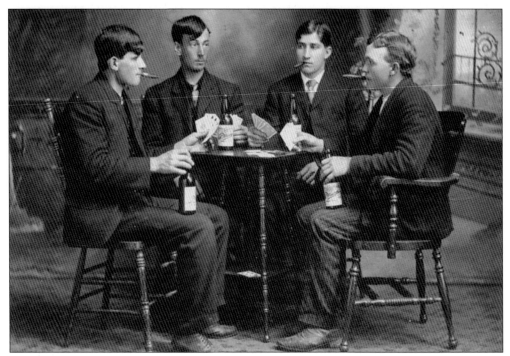

An unidentified group of young men meet for an unknown reason in a photography studio. Is this possibly a bachelor party with the groom and his party enjoying a good cigar and some cards with his buddies? Which one is the groom? Which one looks most nervous? They all appear to be wearing their poker faces. However, they are enjoying St. Marys beer.

Here is another photograph of local residents enjoying St. Marys beer. Again, little is known about the occasion. However, the subjects are both dressed up. Both are wearing white shirts, and one sports a bow tie. Could this possibly be a wedding reception that has spilled out of the reception hall onto the lawn? Card playing and cigars appear to have been popular whatever the case.

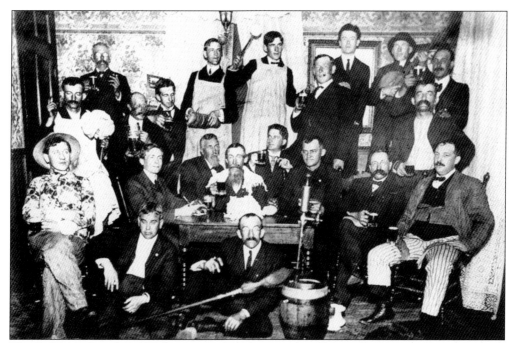

The St. Marys Sauerkraut Klub is pictured performing their duties. There were many clubs, both organized and disorganized, in St. Marys. This club appears to celebrate local brew and culinary arts. Note that some of the chefs are holding homemade bread and a cabbage head. St. Marys is famous for its Christmas smoked-venison sausage. Recipes are closely guarded family secrets passed down from butcher to butcher.

Elk County has one of the few free-roaming elk herds in the east. Reintroduced in 1913, the elk herd almost vanished, but today it is estimated there are over 800 elk thriving. The elk herd has become one of the most important tourist attractions of the St. Marys area. Although they have more than doubled, this photograph is actually two animals standing close together. (Courtesy Dennis McGeehan Wildlife Photography.)

ACROSS AMERICA, PEOPLE ARE DISCOVERING SOMETHING WONDERFUL. *THEIR HERITAGE.*

Arcadia Publishing is the leading local history publisher in the United States. With more than 3,000 titles in print and hundreds of new titles released every year, Arcadia has extensive specialized experience chronicling the history of communities and celebrating America's hidden stories, bringing to life the people, places, and events from the past. To discover the history of other communities across the nation, please visit:

www.arcadiapublishing.com

Customized search tools allow you to find regional history books about the town where you grew up, the cities where your friends and family live, the town where your parents met, or even that retirement spot you've been dreaming about.